P9-ELR-479

IMAGES
of America

HYDE PARK
ILLINOIS

IMAGES
of America

HYDE PARK

ILLINOIS

Max Grinnell

ARCADIA
PUBLISHING

Published by Arcadia Publishing
Charleston SC, Chicago IL, Portsmouth NH, San Francisco CA

Printed in the United States of America

Library of Congress Catalog Card Number: 2001094982

For all general information contact Arcadia Publishing at:
Telephone 843-853-2070
Fax 843-853-0044
E-mail sales@arcadiapublishing.com
For customer service and orders:
Toll-Free 1-888-313-2665

Visit us on the Internet at www.arcadiapublishing.com

CONTENTS

ACKNOWLEDGMENTS

While I take full responsibility for the entire content of the book, no book is possible without the kind attention and patience of numerous individuals. I would like to take this space to thank a few of them: the staff of the Special Collections Department at the University of Chicago Library, Andrea Telli of the Chicago Public Library's Special Collections Division, Robert Mason at the South East Chicago Commission, Peter Skosey at the Metropolitan Planning Council, Paul Petrie, Miriam Perloff, the Chicago Transit Authority, Mary Austin, Suzanne Penn, Alison Boden, Lorraine Brochu, Bernard Brown, John Brinkman, Brian Berry, David Solzman, George Hemmens, the University of Chicago News Office, the staff of the Crerar Computer Lab, Chris Winters of the University of Chicago Library's Map Collection, the staff of the Chicago Maroon, the Hyde Park Neighborhood Club, Joon Park, Jay Shuffield, Andrew Abbott, Tim Banks, Ray Gadke, Jennifer Pitts, Susan Walker, Caitlin Devitt, and the numerous members of the Hyde Park community who agreed to sit down and talk with me through this whole process. I would also like to make special mention of the support of the *Hyde Park Herald* through this whole endeavor. In particular, the assistance of Susan Walker and Bruce Sagan, the publisher of the *Hyde Park Herald*, was invaluable. Mr. Sagan also deserves praise for his efforts to present a balanced and professional approach to journalism that is an absolute necessity in a community with such diverse constituents. In closing, I would like to dedicate this book to my mother and father, who have always offered their love and support.

INTRODUCTION

by Leon Despres

Blessed by its location on the shores of Lake Michigan, 7 miles from the mouth of the Chicago River, the community of Hyde Park has undergone three mega-developments that have given it an extraordinary quality. The first was the far-sighted founding and planning of Hyde Park by its original developer, Paul Cornell, particularly his relentless drive for the creation of a lakefront park, a Plaissance, an adjoining park, and boulevards, which gave the new town the quality it has retained for 150 years. In 1889, Hyde Park voted for annexation to the City of Chicago.

The second great infusion of energy into the Hyde Park community occurred 40 years later with the founding of the University of Chicago in Hyde Park and the construction of the World's Columbian Exposition. The World's Fair not only brought recognition and prestige to the community but also brought an enormous infusion of construction and conveniences to the area. The new university also brought prestige, but as it has grown, it has stamped the community with the value of a great university and has become Hyde Park's most significant employer and landowner.

The third great step forward occurred 50 years later with the community's reaction to the outlawing of racially restricted covenants. For a hundred years, Hyde Park had relied on the exclusion of African-American residents as a device for maintaining the quality of the community. It did not work. The community deteriorated. When the United States Supreme Court declared such covenants illegal and unenforceable, the general community first and the University soon after concluded that the hope of maintaining a viable community lay in welcoming African-American residents and building a community of high standards. Being a century old, Hyde Park was suffering severe deterioration. Working together and often at loggerheads, the community and the University hammered out a development plan with strong city, state, and national financial support, which transformed and rejuvenated the area. It is now more than 50 years since the redevelopment plan was put into effect with much travail and with considerable success.

Max Grinnell has provided a rich store of records of the past to illustrate Hyde Park's exceptional history. No book has ever contained such an extensive record. This little community has added immeasurably to world civilization. If the controlled release of nuclear energy were its only contribution, that would be fantastic.

And what of the future? What's past is prologue.

One

THE URBANIZATION OF HYDE PARK AND WOODLAWN

In 1853, Paul Cornell, a New York lawyer, purchased 300 acres of property from 51st to 55th Streets, which at the time was outside of the Chicago City limits. Even the most zealous of real estate speculators or boosters did not imagine that Hyde Park and its bordering community to the south, Woodlawn, would play host to the World's Fair 40 years later. With an eye towards adding value to his sizable land investment, Paul Cornell deeded 60 acres to the Illinois Central in exchange for a train station and the promise of 12 trips daily to Central Depot in the heart of Chicago's developing commercial core. This mutually beneficial relationship developed through the following decades, increasing the popularity and accessibility of both Hyde Park and Woodlawn throughout the first several decades of the 20th century.

Along with train service provided by the Illinois Central, other transportation improvements aided the continuing development of Hyde Park and Woodlawn in the 1880s. While a Cottage Grove horse-car line had operated from 1859, the speed and carrying capacity of the line was significantly increased when cable cars took over the line in 1882. By 1888, the Cottage Grove line reached south to 67th Street in Woodlawn. Other significant transportation improvements included the 55th Street cable car line, which ran east along 55th Street to Jefferson Avenue (later Harper Avenue), where the line turned south to 56rh Street, continued east to Lake Park Avenue, then went north to 55th Street, where it proceeded westward on its return to Cottage Grove Avenue. The northern part of Woodlawn was served by the 59th–61st Street cable car line (which began service in 1899), which turned around at 60th and Blackstone, proceeding west along 61st Street to State Street, where the line went north to 59th Street and moved into Englewood. Before 1899, there was a 61st–63rd Street line which began at 61st and State, going east on 61st, then south on Cottage Grove, and east again on 63rd to Stony Island Avenue.

Despite transportation improvements, the transformation of the built environment of Hyde Park and Woodlawn was quite modest until the early 1890s. One visitor commented in the *Hyde Park Herald* that he "had never experienced such tranquillity, particularly in such proximity to a bustling metropolis." Hyde Park would never be the site of heavy industry, in part due to the wishes of Paul Cornell, who specifically forbade such developments in the community. The next catalyst for development and change in both areas would be the founding of the University of Chicago and the World's Fair of 1893, which was held in Jackson Park.

With the arrival of the University of Chicago, Paul Cornell's vision of an institution that would serve as an anchor and defining touchstone for the community was complete. Founded in 1890, the University of Chicago benefited from the financial largess of both John D. Rockefeller and Marshall Field, who donated much of the real estate in Hyde Park for the construction of a new campus for the university. Inspired by the spirit of the Gothic architecture that was an integral part of numerous European seats of higher learning, the university's Committee on Buildings and Grounds directed the first campus architect and planner, Henry Ives Cobb, to

utilize this idiom to form the emerging Main Quadrangle and surrounding structures. Clad in limestone, Cobb Hall was the first campus building to be completed—and just in time for the first day of the classes on October 1, 1892. Rising along the southeast corner of the Main Quad at the same time was Foster Hall, one of the first women's dormitories. Foster Hall overlooked a distinctly non-academic enterprise—the Midway, home of the rather raucous and bawdy dances of Little Egypt and other "ethnic displays" being offered as an antidote to the scientific and erudite exhibits in the main World's Fair buildings in Jackson Park.

Outside of the various lectures, displays, and other diversions by the World's Fair, the yearlong event had a profound and lasting effect on the built environment of Hyde Park and Woodlawn. Both Hyde Park and Woodlawn saw the construction of hundreds of buildings designed to house both fair workers and visitors. Some of the buildings were meant to be temporary, like the Artists Colony on 57th Street, while others were built out of more substantial material and featured modern conveniences, such as water heaters and modern indoor plumbing. Along with a recrudescence of building in both areas, the Jackson Park Elevated line was completed by the South Side Elevated Railroad Company on May 1, 1892. By May 27, 1892 the elevated was carrying passengers to 39th Street, and the line finally reached the World's Fair grounds, several weeks after the fair had started. Not wanting to be left behind, the Illinois Central started running express trains from downtown Chicago to the 63rd Street entrance to the fair. In addition, the fair was served by the 63rd Street surface line, which soon became one of the most heavily traveled east-west segments of the system.

Despite a significant building slump in the period immediately after the fair's conclusion in 1893, construction in both places continued vigorously until the late 1920s. By the first decade of the 20th century, a mixed-use pattern of six-flat walk-up apartment buildings, interspersed with larger structures and a variety of commercial uses had become commonplace throughout the area. While both areas seem to develop a heterogeneous land use pattern, certain retail areas developed along streets served by mass transit, most notably 55th Street and Lake Park Avenues in Hyde Park and 63rd Street in Woodlawn. One special land use area was the lakefront and East Hyde Park, which saw the construction of over 100 hotels in the first two decades of the century. The *Hyde Park Herald* reported in 1926 that there were over 150 hotels valued at over $174 million in the Hyde Park and Jackson Park areas. Older buildings originally built for fair visitors maintained their status as fashionable hotels and long term places of residence, although some began to cater to transients, a situation that would become problematic in the 1930s and 1940s.

Throughout this period, the University of Chicago continued with a well-defined building program that was articulated from the very outset of the institution's founding, but soon found itself forced to purchase additional buildings in order to provide adequate housing for both unmarried and married students. On June 19, 1912, the *Chicago Daily News* reported that the university had purchased a four-story walkup building at 61st and Ellis in Woodlawn for married students. The article also mentioned that "the other university dormitories are completely filled," a concern that would remain an important part of the university's substantial building purchases and area investments for the next 50 years.

HYDE PARK HERALD.

VOL. I. NO. 2. HYDE PARK, ILL., JANUARY 21, 1882. PRICE FIVE CENTS.

HYDE PARK.

The Village by the Garden City of the West.

A Great Manufacturing and Industrial Point---Pullman, South Chicago, Grand Crossing and Irondale---A View from the Top of the Great North Chicago Rolling Mills---Various Interesting and Statistical Information.

HYDE PARK.

The village of Hyde Park, Cook County, Ill., is the largest village, both in extent of territory and number of inhabitants, that is to be found in the United States.

It covers about forty-eight square miles of territory, nearly a third more area than embraced in the city of Chicago. It is bounded on the north by Thirty-ninth street, the southern limit of Chicago; on the east by Lake Michigan and the Indiana State line, with a width of from one to five miles; on the west by Lake and Calumet, and on the south by Thornton and Calumet, Within its municipal corporation there are already over twenty distinct settlements and nine post offices.

Its present population is estimated to be nearly thirty thousand, and the increase is very rapid. As a manufacturing center, the village of Hyde Park develops more and more each day, and it has already gained a national reputation by reason of the gigantic enterprises which are being pushed within its borders. It has the most magnificent system of parks in the United States. Within its limits are located the famous South Parks, which cover an area of 1,057 acres, fourteen miles of boulevards, and some thirty-five miles of walks, which have already cost in the neighborhood of ten million dollars while many more millions will be expended before they are perfected.

The waters of Lake Michigan wash about ten miles of the eastern boundary of the village, and afford the most attractive of places for elegant suburban residences. The modern palaces which have been and are to be erected on the lake shore are among the attractions of the village.

Hyde Park is a peculiar village in many respects, and within its borders presents as many varieties of opposites as could well be found. What are known as the north and south ends are as distinctly separate from one another as well could be.

What is known as the South End, is that part of the village which lies to the south of 75th street. It includes the great manufacturing and industrial part of the village, the

The North End is by far the choicest and most elegant part of the village. It includes within its borders the elegant residences of some of the leading merchants of Chicago.

Hyde Park is governed, at present, by six trustees, elected, three every year. While they have done well thus far, the rapid growth of the village evidences, the fact that the accumulation of work is by far too much for six men to attend to, and the idea of a city organization is being agitated. The intention is to divide Hyde Park into seven wards with two aldermen from each. This would give each section representa-tion in the council and make less work for each man.

A VIEW FROM ALOFT.

"What a wonderful country this is!" as Mr. John Walters, proprietor of the London *Times*, made this remark, he turned to Mr. Geo. M.

mentioned persons, Lady Walters, her son, Mr. Ronald McNabb, Mr. O. W. Potter, president of the Rolling Mills Company and a reporter.

'Twas a beautiful autumn day a few months ago, and from their elevated position the party got an un-equaled view of one of the greatest manufacturing districts in the Northwest. To the east, at their feet, old Lake Michigan shimmered in the sunshine, its eastern edge fringed with the sand hills and forests of Michigan. On its placid surface white-winged messengers of commerce floated, while little snort-ing tugs and boats of every descrip-tion plied in all directions. To the north some twelve miles lay Chi-cago, and between the mass of brick and clouds of smoke, which evi-denced the site of the Garden City of the West, were the groves of the South Parks and the handsome resi-dences of the intervening suburbs.

THE CITY OF BRICK

a site, which but a few short years ago was almost a barren waste.

Here at this wonderful city em-ployment is given to very nearly 4,000 people, and a car building works of great proportions has been built. Accommodations for very nearly four thousand people have already been provided, and it is ex-pected that there will be a popula-tion of 20,000 there inside of two years.

At the foot of the party, lay the town of

SOUTH CHICAGO,

with a population estimated to be about 7,000, which by the way, has every prospect of being doubled within a couple of years.

Here are located the largest roll-ing mills in the United States, those owned by the North Chicago Roll-ing Mill Company. The rapid growth of a great national industry is one of the wonders of this new country. Previous to 1870 there was no Bessemer steel produced here. Now the amount produced is esti-mated at 1,000,000 tons of rails, alone, at a value of over $60,000,000. Of rails alone, the North Chicago Rolling Mills produces nearly $15,-000,000 worth annually. It is esti-mated that 500,000 tons of rails can be produced annually at these works.

GREAT ROLLING MILLS.

The North Chicago Rolling Mills were established by Captain E. B. Ward in 1857, upon the site of the present works at North Chicago, with a capital of $200,000. As the demand for its product warranted, the capacity was increased, until 1869, when the North Chicago Roll-ing Mill Company was organized with an authorized capital of $3,000,-000. The capacity of the works were greatly enlarged, and new branches of manufacture added from time to time, until the capacity of the works at North Chicago and Milwaukee now are.

Fish plates	tons	18,000
Merchant bar	do	40,000
Pig metal	do	140,000
Iron rails	do	110,000
Steel rails	do	100,000
		403,000

The great works at South Chicago were located there but a short time ago, and are not yet in full running order. The Company owns about 100 acres on what is known as the "Strand," at the mouth of the Calumet river. Here are located its vast buildings, and here will be built the residences of the Rolling Mill employees.

The Company also owns 20 acres on Stony Island avenue, near by, where it has a quarry, add where it gets the stone which is mixed with the ore in melting.

HOW IRON IS MADE.

A trip through the works is most interesting, and gives a person a vivid idea of the immensity of the

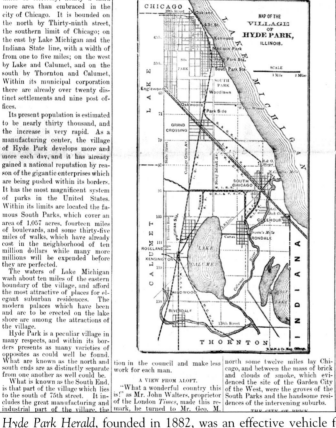

CHICAGO

MAP OF THE
VILLAGE
OF
HYDE PARK,
ILLINOIS.

SCALE
1 Mile 2 Miles

L A K E M I C H I G A N

C A L U M E T L A K E

I N D I A N A

T H O R N T O N

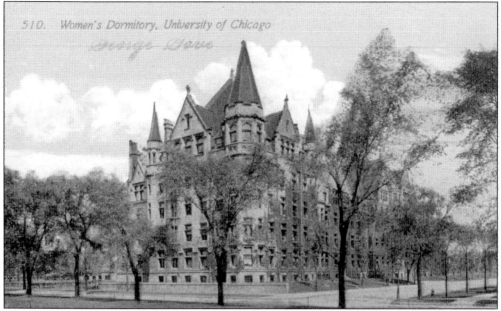

510. Women's Dormitory, University of Chicago

Along with Kelly and Beecher Halls, Foster Hall was one of the first women's dormitories on the University of Chicago campus. The roofline of Foster Hall featured a variety of crockets and grotesques, which seemed to act as deterrents to the less studious activities that were taking place on the Midway as part of the World's Fair during that time. (Private Collection.)

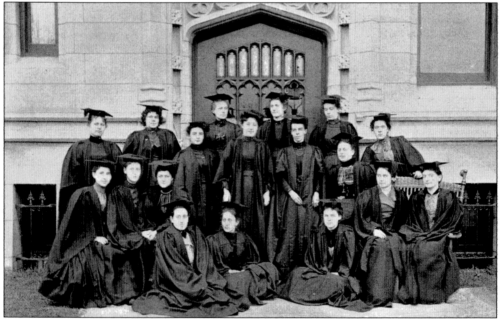

This photograph of the Kelly Hall residents features Marion Talbot (the third woman on the right in the group in front of the doorway), who was Dean of Women at the University from 1892 to 1925. In addition to serving as Dean of Women, she was also the founder of the organization that would later become the American Association of University Women. (Private Collection.)

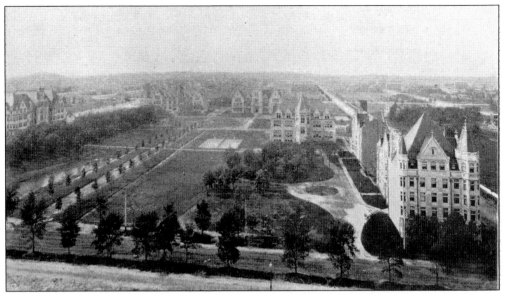

This early view of campus from the Ferris wheel along the Midway shows the initial phase of campus construction at the university. In the immediate foreground is Foster Hall, with the Walker Museum set off to the west of the women's dormitories. Looking north beyond Walker are the Ryerson and Kent Physical Laboratories. At the time of this photograph, private construction outside of the campus in this part of Hyde Park was minimal. (Private Collection.)

GREENWOOD HALL

Responding to a need for additional campus dormitories, the university bought a large apartment building in the 6000 block of South Greenwood in 1910, on the other side of the Midway. Greenwood Hall was the home for approximately 30 women and was owned and operated by the residence hall division of the university for over 25 years. (Private Collection.)

Woodlawn Trust and Savings Bank

Charles M. Poague, President

Charles Poague was a pioneer in Woodlawn real estate and banking for over 40 years. Arriving in Woodlawn in late 1893, Mr. Poague opened an office of the real estate firm McKey and Poague at 63rd and Dorchester. After weathering a rather extended slump in real estate activity, business soon began to pick up once again for the pair. Mr. Poague's most enduring legacy to the area was his effective marketing and selling of the property on the site of the former Washington Park racetrack in 1909. While dealing extensively in Woodlawn real estate, Mr. Poague and his partner, Mr. McKey, purchased the Woodlawn Trust and Savings Bank in 1894, and proceeded to purchase substantial pieces of property throughout the South Side. While the Woodlawn Trust and Savings Bank has ceased to exist, the real estate firm of McKey and Poague continues to do business throughout the area. (Private Collection.)

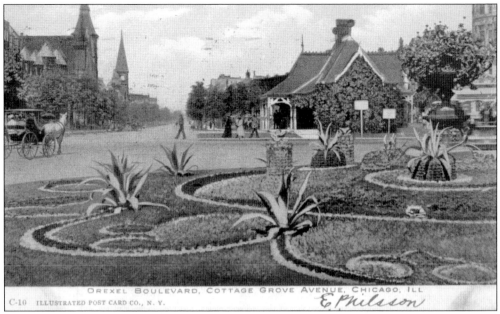

DREXEL BOULEVARD, COTTAGE GROVE AVENUE, CHICAGO, ILL

E Philsson

This early-20th century postcard captures the fountain and landscaping of Drexel Square at what perhaps was its zenith as a well-maintained public space. The land and fountain were both donated by the family of the well-known philanthropist from Philadelphia. Immediately south of Drexel Square are a series of attractive town homes, which date from the first decade of the 20th century. (Private Collection.)

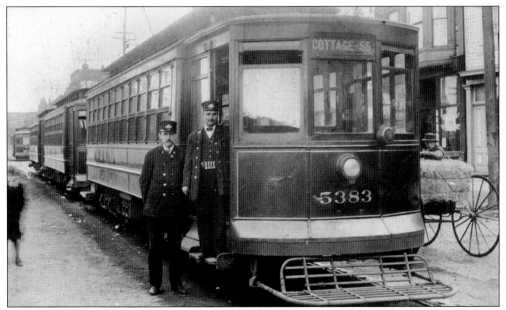

By the late 1880s, horses had ceased to be the preferred power source for mass transit, and the trolley car had come into existence. The Cottage Grove line continued to be a popular transportation option until the entire line was replaced by CTA bus service in 1955. The man on the left in this picture is Clarence Peterson, a motorman who worked on the line for 41 years. (Chicago Transit Authority.)

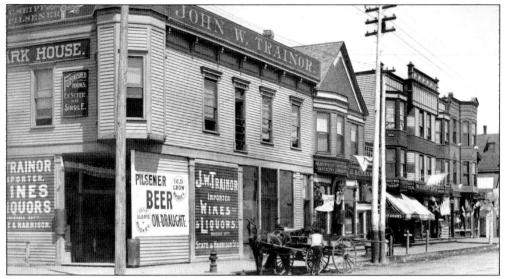

This photograph of the popular Trainor's Tavern at 56th and Lake Park Avenues is representative of the types of buildings that were constructed in anticipation of the World's Fair. While Trainor's had been on the site for close to a decade, some of its neighbors were built in order to capitalize on the anticipated surge of business expected from the millions of anticipated tourists and sojourners to the area. Interestingly enough, the area between 54th and 56th Streets on Lake Park Avenue had over 15 taverns due to a village law passed in 1877, which forbade their presence elsewhere in that part of Hyde Park. Recent infrastructure developments are visible in this photograph, including fire hydrants and the recently renovated 55th Street trolley tracks, which led to a turning area at nearby Cable Car Place. (Department of Special Collections, Chicago Public Library.)

The Home for Aged Jews of Chicago

Drexel Avenue and Sixty-second Street

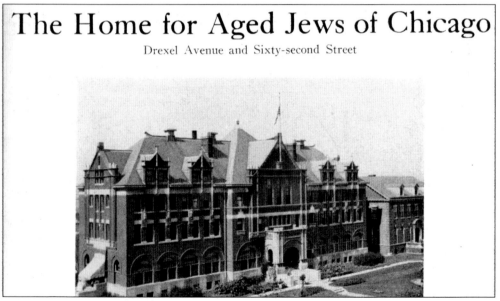

Erected in 1903, the Home for Aged Jews was built to serve a small but growing population of elderly Jews in the Hyde Park and Woodlawn communities. Several years before, in 1899, the Chicago Home for Jewish Orphans was opened at 6208 South Drexel Avenue. Both institutions remained viable until the 1970s. (John C. Spray.)

The interior of the Hyde Park YMCA was well appointed to meet the needs of both club members and long term guests. Besides the game room, which featured pool tables, young men were welcomed around the fireplace to talk about various issues of the day, or to attend Bible discussion. On one occasion, the members of the Bug Club (which was a group of self-professed atheists who met in nearby

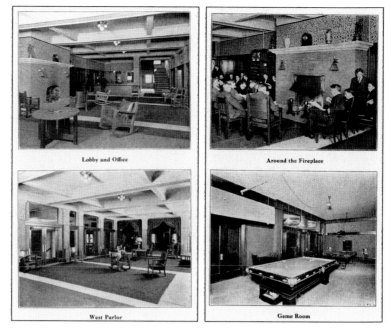

Lobby and Office

Around the Fireplace

West Parlor

Game Room

Washington Park) got into a rather heated discussion about repealing the 18th Amendment. Needless to say, the young men of the YMCA were staunchly in favor of the recently enacted amendment, and the Bug Club coterie found its very existence "an affront to free-spirited citizens everywhere." (Department of Special Collections, Chicago Public Library.)

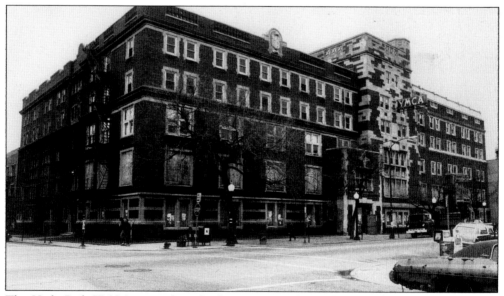

The Hyde Park YMCA opened in the late 1910s, and was designed to support the mission of the George Williams College (at 53rd and Drexel), whose primary mission was to train their students to manage and direct the activities of YMCAs around the United States. As membership in the local branch dwindled in the late 1970s, the building was shuttered in 1980, and demolished in 1983. It was replaced shortly afterwards by a small and nondescript strip mall project. (Department of Special Collections, Chicago Public Library.)

17

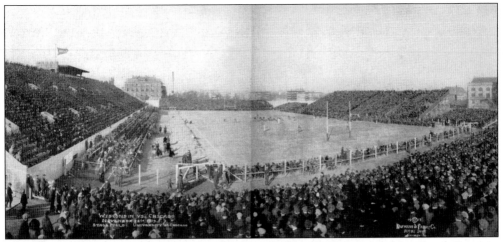

This photograph was taken from the south stand of Stagg Field (renamed for Coach Stagg in 1913). Despite personnel losses to World War I, the University of Chicago football team posted a 5-2 record for the 1919 season. On the far right is Bartlett Gymnasium, completed in 1903, and dedicated to physical culture. In the far distance beyond the north stand is the Chicago Home for Incurables, which provided medical assistance and long term care for those given the unfortunate designation of "incurable." While the new north stand of Stagg Field was a blessing for the throngs of spectators who wanted to see the Maroons, Coach Stagg expressed a very strong desire for additional practice space for the football team in a letter to the business manager of the university. In the letter from Stagg, he requested that the university purchase the remainder of the land in the 5600 block of Ellis Avenue so that the team might have more practice space. While the university already owned all of the property along Ingleside Avenue in that block, Stagg's request went unheeded, largely due to the fact that there were already plans to place the botany greenhouses in that block. (Private Collection.)

Named after the man who gave the original gift of land to the university, Marshall Field sat between 56th and 57th Streets, and University (then Lexington) and Ellis Avenues. By 1903, Coach Amos Alonzo Stagg had acquired a formidable reputation in the world of intercollegiate football, and that year the Maroons only lost two games the entire season. Along the way they racked up substantial margins of victory, including one drubbing of Monmouth College, 108-0. (Private Collection.)

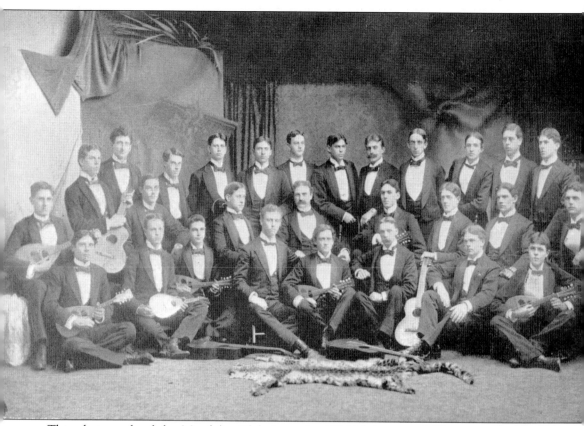

This photograph of the Mandolin Club from the 1896 University of Chicago yearbook is representative of the diversity of student activities that existed from the institution's inception. Only four years after the first academic year, there were over 40 clubs which focused on elocution, dramatics, and a host of other leisure pursuits. Musical groups were quite popular, and the fact that there was in fact a mandolin factory in Chicago at the time probably was helpful to aspiring instrumentalists. (Private Collection.)

Finished in 1926, the Shoreland Hotel boasted a bowling alley, a full service hair salon, a restaurant, a coffee shop, and two ballrooms. In this photograph, the oval-shaped garden in front of the main entrance featured a fountain and statuary. Notable due to its absence in this photograph, the Outer Drive would not be expanded for over a decade. The hotel was also the site of numerous community meetings, including those of the 55th Street Businessmen's Association and the Hyde Park Chamber of Commerce. (Department of Special Collections, Chicago Public Library.)

The construction of the Shoreland, which began in late 1925, was a lengthy and expensive affair, and ran into significant cost-overruns. This photograph was taken in early 1926, and was featured in the "Shoreland Hotel Bulletin," which gave the various contractors who worked on the hotel an opportunity to promote their company or product. Other advertisements in the same brochure featured kitchen fixtures, showerheads, and not surprisingly, automatic pin return machinery for the small bowling alley in the building. (Department of Special Collections, Chicago Public Library.)

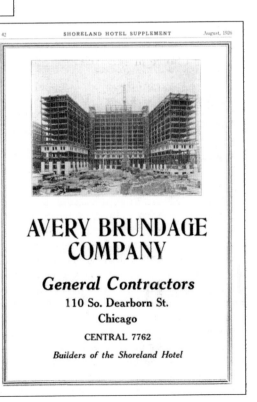

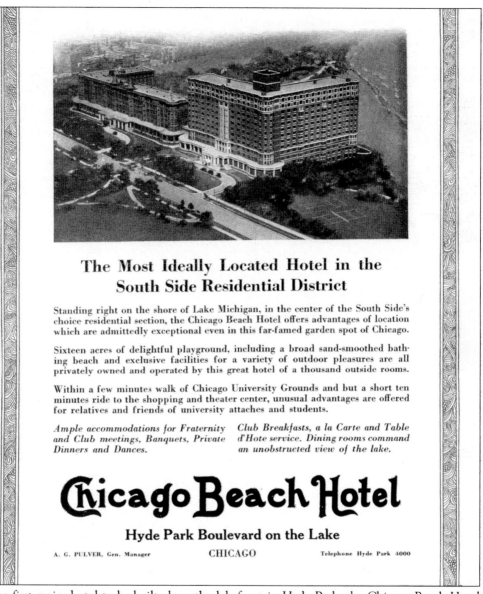
The first major hotel to be built along the lakefront in Hyde Park, the Chicago Beach Hotel boasted several ballrooms and a number of in-house restaurants. The early 1920s were a propitious time to build a major resort hotel along the lakefront due to the increased service to the Loop by way of the Illinois Central, which ran some 200 trains daily from Hyde Park. Like many of the hotels in the area, the Chicago Beach catered heavily to university groups and offered special discounts to guests of the university. While the hotel enjoyed great success during the 1920s and 1930s, it was purchased by the U.S. Army for use as a barracks during World War II. After the conclusion of World War II, the hotel did not go back into private hands, but rather was used as the headquarters for the Fifth Army unit for 20 years. After this period, the General Service Administration sought to find a buyer for the building, but by this point the market for hotels in Hyde Park had diminished significantly, and the university had solved most of its previous student housing shortage. The building was razed in the late 1960s, and a modern two-towered apartment building stands on the site. (Private Collection.)

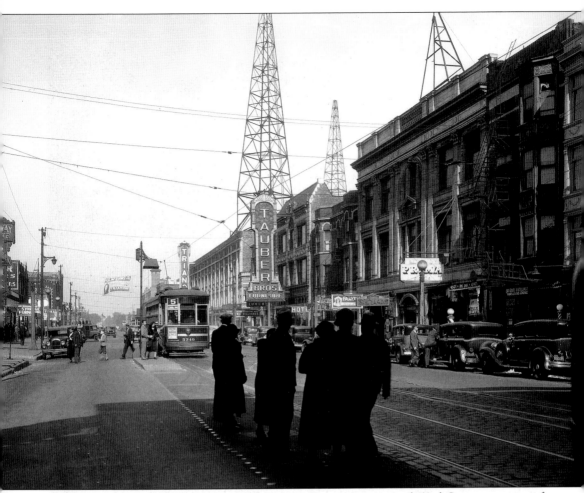

In the early 1920s, the intersection of Cottage Grove Avenue and 63rd Street was one of the most vibrant centers of retail activity on the South Side. While the area did not draw shoppers from the Loop, it did serve as an effective shopping center for the Washington Park, Woodlawn, and Hyde Park communities. Looking northwards, one could see the Trianon Ballroom, designed by noted movie palace architects Rapp and Rapp, who also designed the Windermere East Hotel, which overlooked the Fine Arts Building in Jackson Park (now the Museum of Science and Industry). The towers on the commercial buildings on the east side of the street were for radio transmission; in addition, the Trianon sponsored several radio shows that featured the Dick Jurgens orchestra. The entire section shown in this photograph was largely demolished for a housing project developed by the Woodlawn Organization in the late 1960s. (Chicago Transit Authority.)

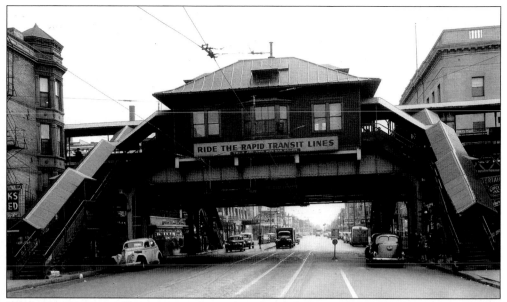

While the Trianon offered various large shows and dancing, there were a variety of other entertainment options along Cottage Grove Avenue. Immediately beyond the El station was the Pershing Hotel on 64th Street and Cottage Grove, which played host to a variety of jazz artists and orchestras throughout its long history. Contrary to what is commonly believed, 63rd Street was host to a far wider variety of entertainment options than 55th Street in Hyde Park. (Chicago Transit Authority.)

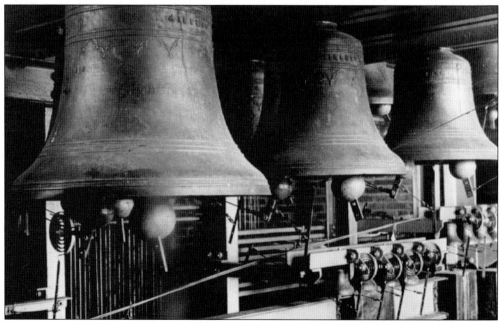

These bells were installed for the carillon of Rockefeller Chapel (then University Chapel) in 1932. Specially tuned, these bells have served the university community for close to 70 years. Each year, carillonneurs from around the world are invited to perform at the annual summer concert series at the chapel. (Rockefeller Chapel.)

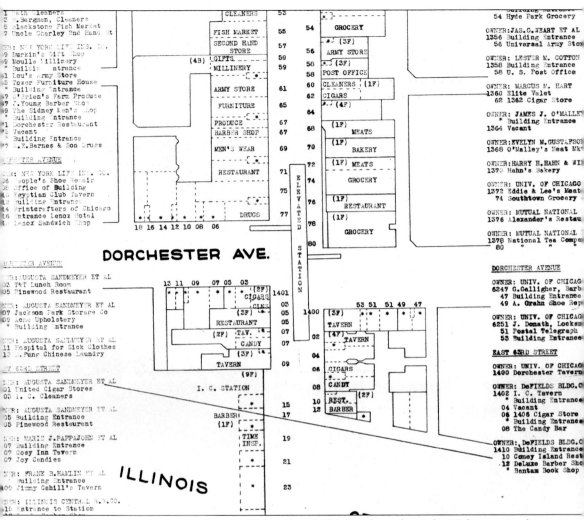

As the social sciences matured at the University of Chicago throughout the 20th century, they turned their attentions to the Hyde Park community and the surrounding area. The Department of Sociology sponsored numerous research projects throughout the 1920s, including a study on apartment house dwellers and another on juvenile delinquency in Hyde Park. While the exact intention of this particular exercise in land use mapping is unknown, this map was produced by an individual in the Sociology Department sometime in the mid-1920s. This particular piece of the map of 63rd Street shows a thriving retail district, with a diverse set of businesses and other land uses, including the nine-story Illinois Central Railroad office building (in the lower left-hand corner). While the ownership of certain properties along this stretch of 63rd Street by the University of Chicago is somewhat inexplicable, it was not uncommon for the university to receive bequests of buildings or other properties from alumni or other parties. Regardless, properties owned by the university in this part of Woodlawn were considered extraneous and were disposed of quickly. (Map Collection, University of Chicago Library.)

In 1928, the university finished construction of the University Chapel. Its completion was the fulfillment of John D. Rockefeller's final bequest to the university of $10 million, which stated that $1.5 million be used to build a university chapel. While the figures on the exterior south frieze are quite elaborate, the interior of the chapel was somewhat more subdued and somber. (Rockefeller Chapel.)

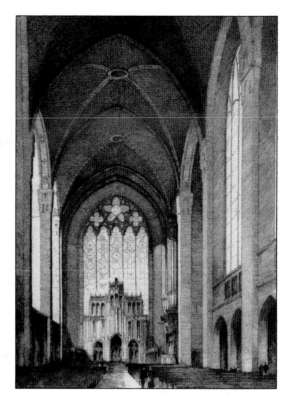

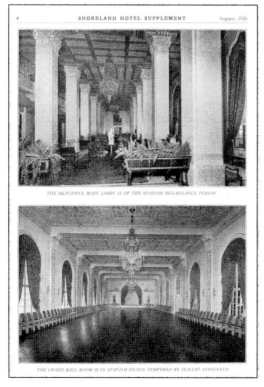

THE BEAUTIFUL MAIN LOBBY IS OF THE SPANISH RENAISSANCE PERIOD

THE GRAND BALL ROOM IS IN SPANISH DESIGN TEMPERED BY ITALIAN INFLUENCE

The Shoreland Hotel at 55th and the lakefront featured a variety of public areas that were available for rent and for the use of guests. The top photograph is a view of the main lobby, complete with heavy Oriental rugs and well-placed vegetation. While the lobby was significantly altered after the building's conversion into a University of Chicago undergraduate dormitory, the ballroom has retained much of its original furnishings, including several chandeliers. (Department of Special Collections, Chicago Public Library.)

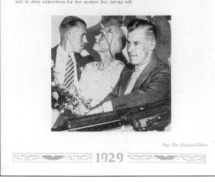

Hyde Park High School has been the incubator for a wealth of talent throughout its history, but no alumna ever received such a heroine's welcome as Amelia Earhart did when she returned to visit in 1929. Not long after her famous trans-Atlantic flight, she returned to Hyde Park High School. The coverage in the *Hyde Park Herald* was quite extensive, as numerous business organizations sponsored a parade across 55th Street, then down Stony Island Avenue to the grounds of Hyde Park High. Upon her arrival at the school, Amelia was offered the key to the school by the principal, and then offered a few remarks to the students on the importance of education. Afterwards, the Hyde Park High School Aviatrix Club showed Ms. Earhart their plane, which was flown in especially for her visit. (Department of Special Collections, Chicago Public Library.)

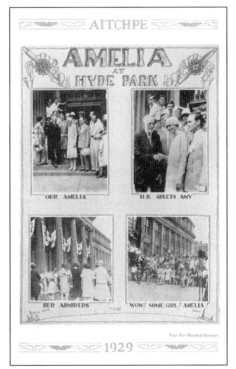

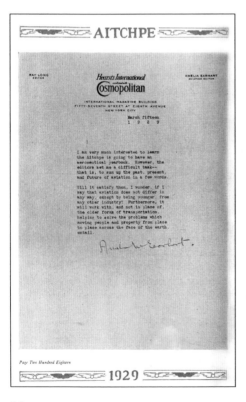

Addressing a letter that asked her to comment on the future of aviation, Amelia Earhart replied to the *Aitchpe* staff that, ". . . it will work with, and not in place of, the older forms of transportation." Needless to say, the 1929 yearbook was dedicated to Ms. Earhart and the "spirit of aviation." (Department of Special Collections, Chicago Public Library.)

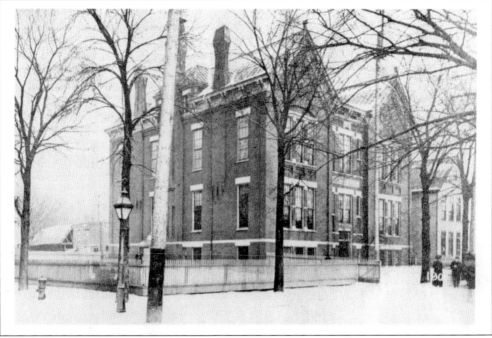

This grammar school building was pushed into functioning as a branch of Hyde Park High in 1897, to accommodate the influx of high school students in the Hyde Park area. While the building was of solid construction, it gradually fell into disrepair, and was eventually razed for the construction of the Murray School at 54th and Kenwood. (Department of Special Collections, Chicago Public Library.)

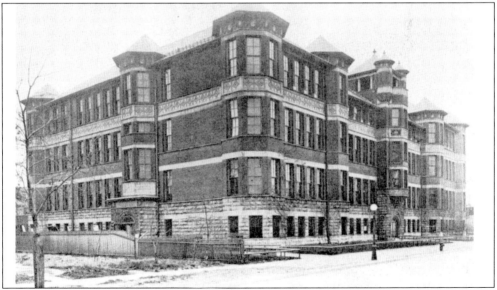

The venerable Ray School building started life as the new home for the Hyde Park High School in 1893. Designed in the mildly exuberant Queen Anne idiom, the building became a grammar school after the completion of the neo-Classical-styled Hyde Park High building at 62nd and Stony Island in 1913. (Department of Special Collections, Chicago Public Library.)

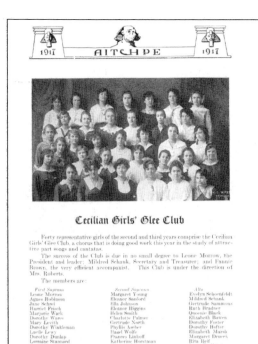

Cecilian Girls' Glee Club

Forty representative girls of the second and third years comprise the Cecilian Girls' Glee Club, a chorus that is doing good work this year in the study of attractive part songs and cantatas.

The success of the Club is due in no small degree to Leone Morrow, the President and leader; Mildred Schank, Secretary and Treasurer; and Fannie Brown, the very efficient accompanist. This Club is under the direction of Mrs. Roberts.

The members are:

First Soprano	Second Soprano	Alto
Leone Morrow	Margaret Young	Evelyn Schoenfeldt
Agnes Robinson	Eleanor Sanford	Mildred Schank
Jane Schwi	Ella Johnson	Gertrude Sammons
Harriet Frisch	Eleanor Higgins	Ruth Bradner
Marjorie Wark	Helen Smith	Queenie Black
Dorothy Wares	Charlotte Palmer	Elizabeth Bowen
Mary Levith	Gertrude North	Dorothy Foster
Dorothy Winkleman	Phyllis Aseher	Dorothy Hefter
Lucile Lewy	Hazel Wolfe	Elizabeth Marsh
Dorothy Dunlap	Frances Linloff	Margaret Drewes
Lorraine Stannard	Katherine Horstman	Rita Reif
Fannie Brown	Florence Loventhal	Irene Faulkner
Alice Stehlets		
Germaine Edwards		

Like many other high schools across the United States, Hyde Park High looked to the activities of their older peers in college when forming student groups and organizations. The 1917 Glee Club was under the advisement of the University of Chicago Glee Club, and they combined for several concerts that year—one at Mandel Hall and one at the high school's auditorium. (Department of Special Collections, Chicago Public Library.)

In a move that would become almost a prerequisite for almost any worthy high school yearbook, the editors of the 1917 *Hyde Park Aitchpe* offered their predictions for the future on one of the annual's back pages. Not surprisingly, the columns are filled with the accomplishments of their classmates (and themselves). What is perhaps most interesting is that they did not foresee women's suffrage becoming a reality until the year 1940. (Department of Special Collections, Chicago Public Library.)

The Chicago Daily World

CIRCULATION OVER 1,000,000 (Combined With The Tribune and The News) CIRCULATION OVER 1,000,000

Vol. X Chicago, Ill., May 25, 1940—Morning Edition No. 136

COOKSY EQUAL SUFFRAGE BILL PASSES SENATE
SWETT WINS AROUND-THE-WORLD RACE FOR UNITED STATES

By 1951, Hyde Park High School had seen its share of notable alumni pass through its halls. Besides Amelia Earhart, other well known alumni include Mel Torme, Steve Allen, and Herb Kent, "The Kool Gent." Within the next decade, the school would soon be bursting at the seams as the population of Woodlawn began to grow at a fantastic rate. (Department of Special Collections, Chicago Public Library.)

Constructed in 1913, Hyde Park High was too small to accommodate both the high school-age youth of Hyde Park and Woodlawn the day it first opened. By 1927, the school was extremely overcrowded, as a building designed to serve 2,000 students actually saw its enrollment exceed 4,000, a state of affairs that continued through the 1930s. After a substantial building campaign (and the support of noted alumnus Harold H. Swift), an addition was completed onto the main building in 1939. (Department of Special Collections, Chicago Public Library.)

The staff of the Aitchpe, the annual of Hyde Park, invites you to browse at your leisure through the pages of annuals on display in Room 328, the new quarters of the staff.

If you belonged to a former annual staff, please register in the guest book and give your year and position.

Be sure to view the photographic exhibit of current activities, particularly athletics.

This 1939 piece of promotional literature for the Hyde Park High School annual, the *Aitchpe*, is representative of the importance of the annual within the local community. News briefs in the *Hyde Park Herald* emphasized the value of placing advertisements in the back of the *Aitchpe* to ensure that "local students will patronize your business for years to come." (Department of Special Collections, Chicago Public Library.)

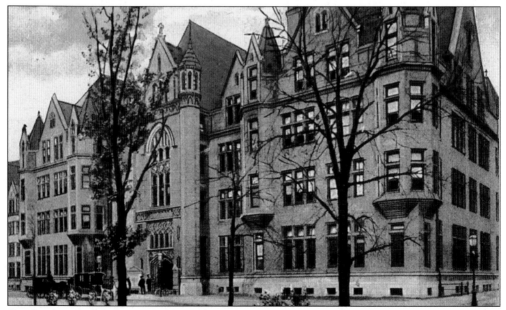

On the first day of classes, Cobb Hall was the only building open on the university's campus. Initially, all of the classrooms and administrative offices of the university were located within the building. Before a complete interior renovation of the structure, it featured a large wooden staircase as its prime mode of interior circulation. (Private Collection.)

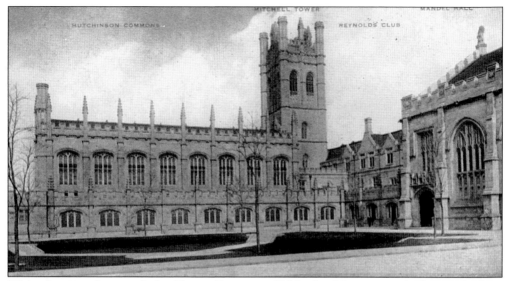

With the completion of the Tower Group in 1903, the University of Chicago had an outstanding quartet of buildings devoted to student activities and dining. Deriving much of their basic architectural form from structures within the Oxford College system, the buildings themselves used different elements in both a creative and flexible fashion. The northeast corner of the Main Quadrangle was now complete. (Private Collection.)

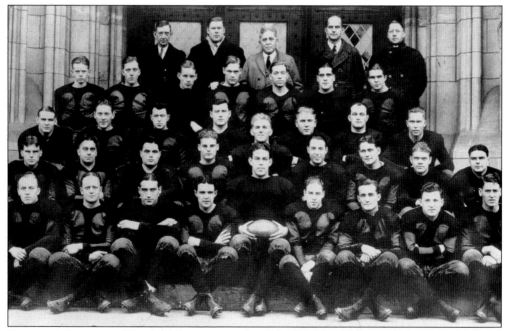

Sitting on the steps of Bartlett Gymnasium, the 1924 Big Ten Conference champion Maroons enjoy what would unfortunately be their last conference title. Amos Alonzo Stagg, the "Grand Old Man of Football," is third from the left in the back row. While Stagg Field would cease to be used for Big Ten football after the dismal 1939 season (including losing to the University of Michigan, 85-0), the West Stands would later be the site of the first self-sustaining nuclear chain reaction under the supervision of Enrico Fermi and his colleagues. (University of Chicago News Office.)

The George Williams College, named after the founder of the YMCA, was an institution devoted to teaching young men and women how to run and administer physical education programs. The rather imposing building was built in 1915, and stood at 5315 South Drexel Avenue. The building contained a complete complement of facilities, including a gymnasium, dormitory space, classrooms, and a refectory. The building was an ideal institution to anchor the northwest corner of Hyde Park, and as such was offered a sizable portion of land during the discussion about the extent of urban renewal in that area of the community. Finding themselves hemmed in by other developments, such as walk-up apartment buildings and some single-family homes, the college purchased land in Downers Grove and moved there in 1966. The building was purchased by the University of Chicago and used as a temporary dormitory facility and for its well-kept athletic facilities, including an outside track that ran in front of the building. The building was later demolished and replaced in 1991 by a modern town home development that deployed a rather unusual color scheme, even if it did match the scale of the surrounding residences. (Private Collection.)

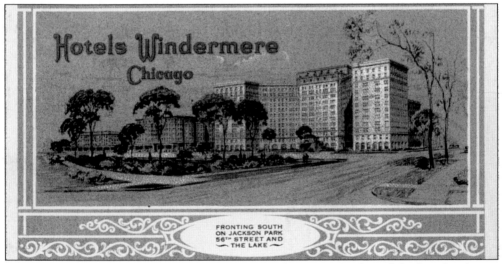

With the completion of the Windermere East Hotel in 1924, Hyde Park had its first luxury elevator building overlooking Jackson Park and the Fine Arts building. Designed by Rapp and Rapp, who were known for their skillful execution of movie theaters and performance venues, the building remains an extremely popular rental location today. The Windermere West was eventually demolished to provide a parking lot and additional space for the nearby Bret Harte Grammar School. (Private Collection.)

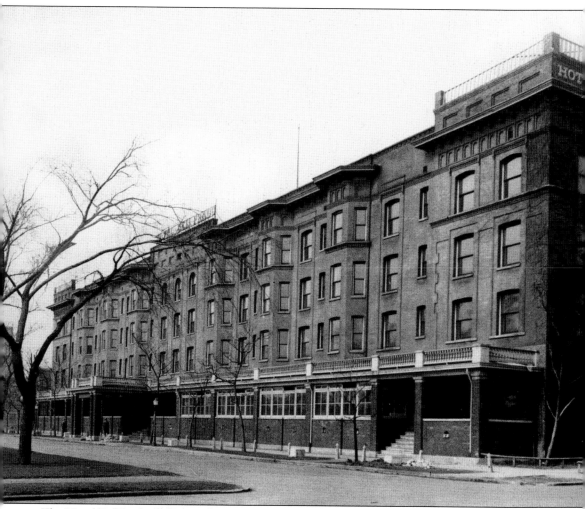

The Hotel Del Prado at 59th and Dorchester was built to accommodate crowds from the World's Fair, and it remained a popular option for long-term habitation long after the fair was over. Many professors from the university lived there, including Nobel Prize winner Albert Michelson. The first-floor sun porches were for guests who wanted some respite from the stifling heat that could be such a problem in the building. As the hotel was meant to be somewhat "temporary," the building only had one refectory and a small entertainment room. The Del Prado also played host to numerous university guests, and for a time it was one of the more preferred hotels in Hyde Park. The building was demolished in 1930, so that the University of Chicago could begin construction of the International House, a dormitory designed to accommodate students and other visitors from across the country and the world. (Department of Special Collections, Chicago Public Library.)

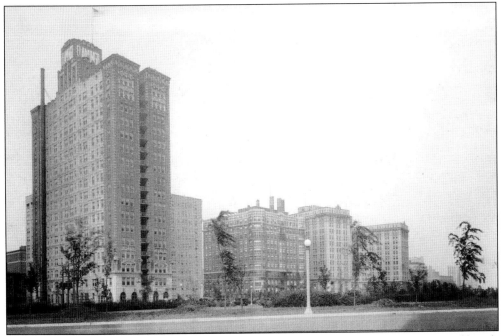

Looking northwards across Leif Erickson Drive in 1930, one can see the expanse of hotels that served tourists throughout Hyde Park. On the immediate left is the Flamingo Hotel, finished in 1928. While the Flamingo did not have the opulent public spaces of other Hyde Park hotels, it did have such modern novelties as a mail chute and a modern garbage disposal system. Also pictured is the Shoreland Hotel, finished in 1926. (Department of Special Collections, Chicago Public Library.)

This view south from Myrtle Avenue (now Minerva) from 64th Street in 1887, was a pleasant reminder of Woodlawn's rather tranquil past. From the 1860s to the early 1890s, much of southern Woodlawn consisted of simple frame houses with large front lawns. As the demand for commercial and retail services increased exponentially, many of these homes would eventually be sacrificed for other land uses. (Department of Special Collections, Chicago Public Library.)

Many buildings were put up quickly in Woodlawn during the 1890s, and this photograph gives ample evidence of the rapid change in the community. While the brick commercial two and three-story buildings that would later line 63rd Street are not yet present in this 1894 photograph, there are a substantial number of residential and hotel properties already completed. This photograph looks northwest from 63rd and Kenwood (then named Monroe Avenue). The two-year-old Gladstone Hotel is present on the right side of the picture. (Department of Special Collections, Chicago Public Library.)

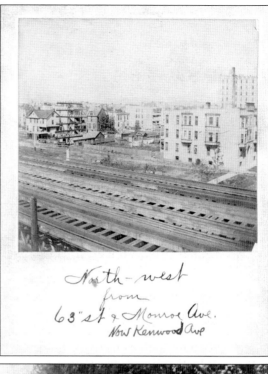

North-west
from
63"st & Monroe Ave.
Now Kenwood Ave

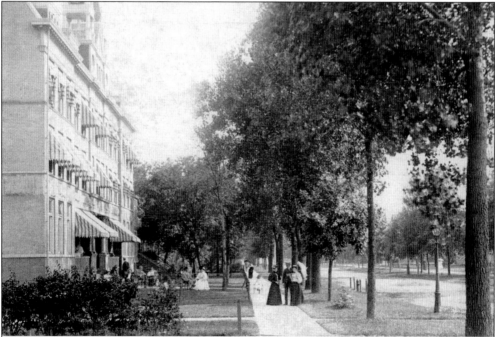

The Colonial Hotel at 6325 South Kenwood was one of the first World's Fair hotels to be located south of 63rd Street. Earlier entrepreneurs had expressed doubts that such a location would be successful, and older residents who wanted to keep southern Woodlawn a more bucolic reminder of its recent past were somewhat reticent about allowing "common rooming houses" into their midst. (Department of Special Collections, Chicago Public Library.)

The photograph is somewhat scratched, but this late 19th century image of the transportation nexus on 63rd Street is quite dramatic. The Jackson Park Elevated is crossing over the Illinois Central tracks and roadbed, which in turn crosses over the 63rd Street streetcar line. These three transportation options would be available to residents of Woodlawn and Hyde Park for well over half a century. (Department of Special Collections, Chicago Public Library.)

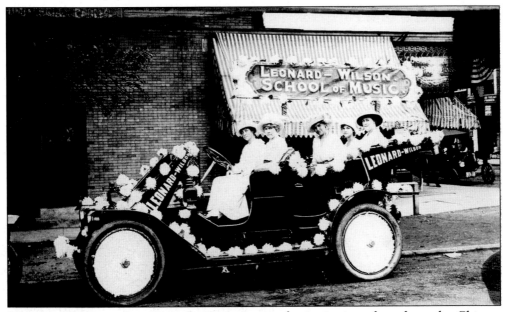

Schools of "music and expression" were quite popular institutions throughout the Chicago area during the first two decades of the 20th century. One such school was the Leonard Wilson School of Music and Expression, which specialized in the teaching of voice and piano. Located at 6255 South Kimbark, the school was founded in 1908, and remained a fixture in the Woodlawn community for three decades. In this photograph, founder Alma E. Wilson is sitting in the very rear of the automobile. Various trade and vocational schools were commonplace in Hyde Park and Woodlawn. Another institution was the MacCormac School, which focused on preparing young men and women for careers in business. The school was founded in 1904, with offices on 63rd Street, and later moved to the Loop to become MacCormac College. Perhaps its most notable legacy is Kate Turabian, an alumna of the school and the editor of the *Chicago Manual of Style*. (Department of Special Collections, Chicago Public Library.)

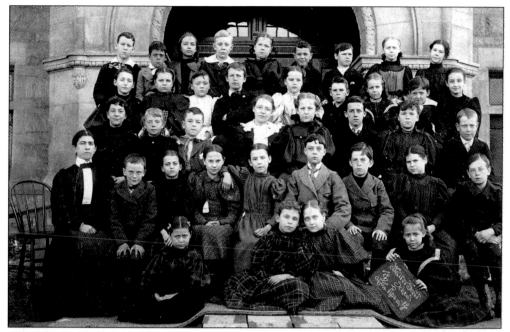

Along with Hyde Park, Woodlawn had excellent educational facilities immediately after annexation in 1889. One of the first schools built for Woodlawn (which had a population of approximately 20,000 at the turn of the century) was the Walter Scott Grammar School at 6435 South Blackstone Avenue. Pictured here are the members of the first graduating class of 1896, the school's first year of operation, in front of the school's main entrance. (Department of Special Collections, Chicago Public Library.)

This home at 6140 South Kimbark Avenue was built around 1890, and is a good example of the single-family house stock that was built in Woodlawn during this time. The brick chimney is a bit unusual in its use of layered bricks to create a tapering effect. (Department of Special Collections, Chicago Public Library.)

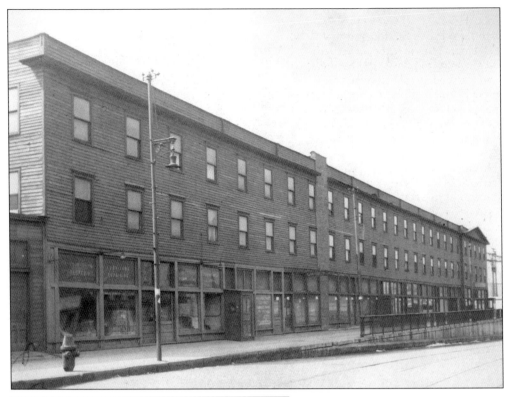

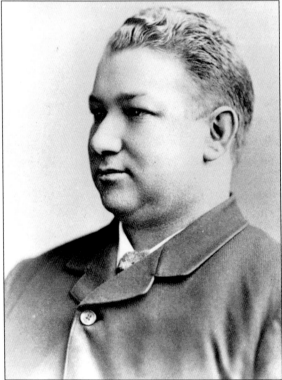

This frame structure was built immediately before the World's Fair in order to house workers on the second floor, and to provide retail space for businesses that would provision the workers. Long ignored at the corner of 71st and Cottage Grove Avenues, the building recently has been restored to its original condition and will shortly be occupied. (Department of Special Collections, Chicago Public Library.)

John Hayes Sr. was one of Woodlawn's first hotel operators, starting with his own Hayes Hotel, which he built in 1892 at 64th and Woodlawn. The Hayes Hotel was full during the World's Fair, and at the fair's conclusion, plans were drawn up to build an annex onto the original structure. As Mr. Hayes died in 1896, the task of building this planned addition fell to his sons, John and Frank Hayes. (Department of Special Collections, Chicago Public Library.)

John Hayes was the son of the late John Hayes Sr., founder of the Hayes Hotel. After his father's death, John took over the business and finished an addition that brought the total number of rooms in the hotel to 160. Perhaps more significantly, John Hayes was the longtime head of the Woodlawn Businessmen's Association. This association was charged with creating a better business climate in the community, along with enforcing the restrictive covenants in the area, which effectively prohibited individuals from renting or selling property to African Americans. (Department of Special Collections, Chicago Public Library.)

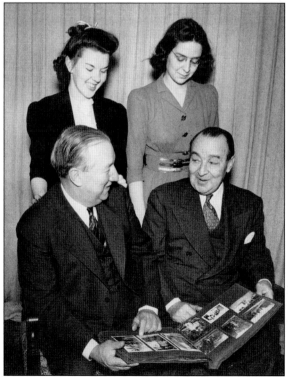

John Hayes Jr. and Frank Hayes (his brother) look over a photo album documenting the 50-year anniversary of the Hayes Hotel in 1942. Standing over the two are their wives, who also worked at the hotel. (Department of Special Collections, Chicago Public Library.)

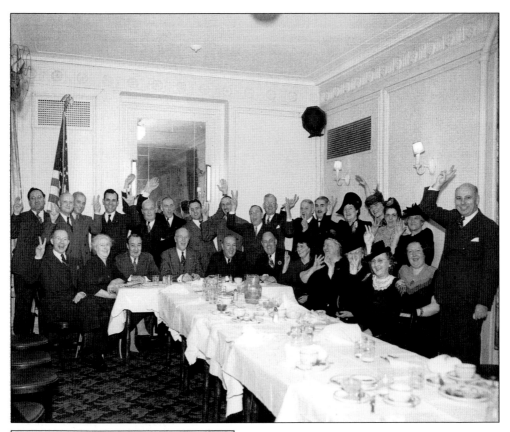

During the 50th Anniversary Celebration for the Hayes Hotel in 1942, members of the Hayes family and guests salute the war effort by making the "V for Victory" hand gesture. (Department of Special Collections, Chicago Public Library.)

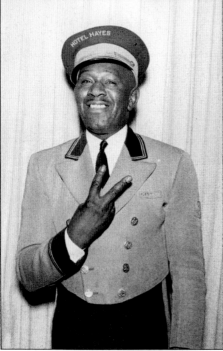

Joe Williams, the longtime head bellboy at the Hotel Hayes, offers his victory sign for the camera at the Hotel Hayes' 50th Anniversary Celebration. While African Americans were allowed to work in Woodlawn, there were very few allowed to live in Woodlawn east of Cottage Grove Avenue, due to the vigorous pressure on property owners not to rent to those not of the "Caucasian race." Despite these pressures, almost 12,000 African Americans lived west of Cottage Grove Avenue, an area that had not been as quick to respond to the influx of African Americans from both the South and increasingly overcrowded areas in the older "Black Belt" around State Street. (Department of Special Collections, Chicago Public Library.)

The Wedgewood Hotel was another attempt in Woodlawn to capture a portion of the tourist trade that began to frequent the beaches and nearby resort hotels of the South Side. While the 1920s building was able to remain solvent throughout the late 1940s, it increasingly found itself relying on a transient clientele that was more likely to be found in the nearby taverns on 63rd Street rather than the upscale ballrooms on the lakefront. (Department of Special Collections, Chicago Public Library.)

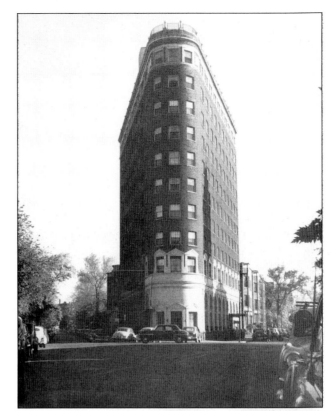

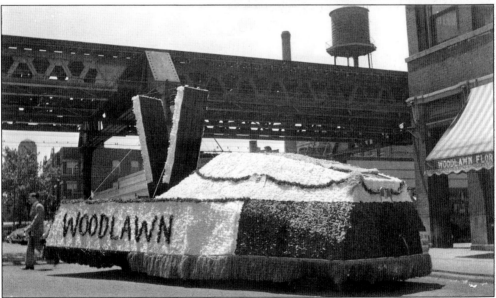

The Woodlawn Businessmen's Association sponsored a Victory Parade in the summer of 1944, and the Woodlawn Florist gladly obliged by providing this float which showcased some of the flowers from their shop. Parades were quite common throughout the community, and one particular parade that year attempted to pit Hyde Park and Woodlawn against each other in friendly competition. (Department of Special Collections, Chicago Public Library.)

This view from the Gladstone is looking north towards the Midway and the University of Chicago campus. Rockefeller Chapel is visible, as is the roof of Ida Noyes Hall, which is to the right of the chapel. (Department of Special Collections, Chicago Public Library and Sherwin Murphy.)

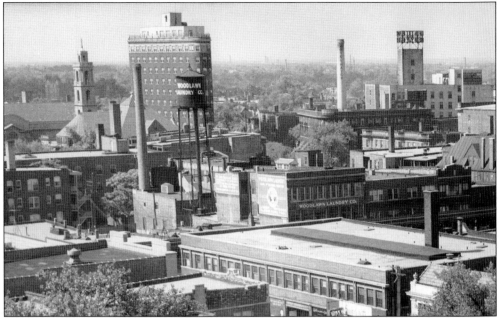

This photograph was taken from the roof of the Gladstone Hotel at 62nd and Kenwood in 1951. The Gladstone was yet another hotel built in 1892 to capitalize on the popularity of the nearby World's Fair. The Hotel Hayes, another Woodlawn hotel, is visible on the right side of the photograph along with the 63rd Street Elevated tracks. (Department of Special Collections, Chicago Public Library and Sherwin Murphy.)

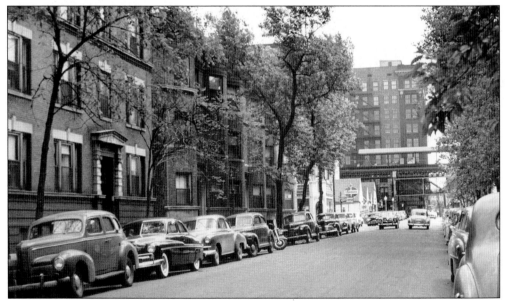

Again the photographer is near the base of the Gladstone Hotel at 62nd and Dorchester, looking towards the 63rd Street Elevated. In this picture, the Dorchester station is clearly visible. After service was terminated to Stony Island Avenue in 1982, Dorchester Avenue was the last stop on this section of the Elevated. (Department of Special Collections, Chicago Public Library and Sherwin Murphy.)

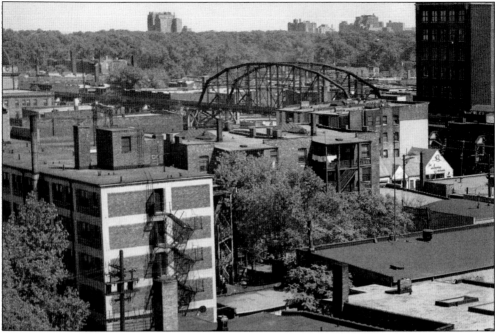

This shot was also taken from the Gladstone Hotel looking to the southeast in 1951. The Illinois Central administrative building is visible on the right side of the photograph. In the far distance, across Jackson Park, are the luxury apartment buildings along 67th Street in the Jackson Park Highlands. (Department of Special Collections, Chicago Public Library and Sherwin Murphy.)

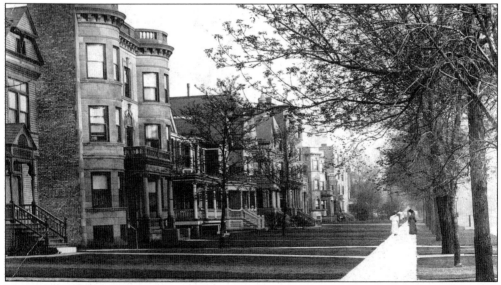

The southern half of Woodlawn tended to resemble the Kenwood area, with large lawns and setbacks being the rule of the day, rather than buildings that came right up to the sidewalk. Additionally, there were few buildings that housed both retail and commercial facilities. While most of the lots were small, they tended to favor the construction of single-family dwellings. This photograph is of the 6400 block of South Kimbark Avenue looking south around 1910. (Department of Special Collections, Chicago Public Library.)

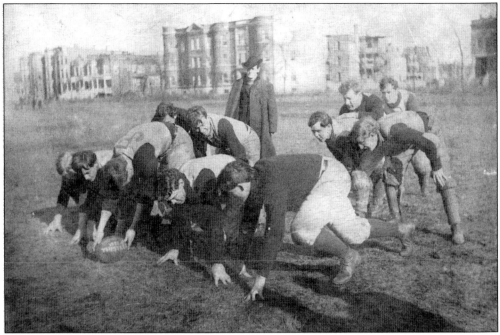

The Woodlawn Thistles were a club football team that played the local YMCA team and other teams, including the team at Hyde Park High. While the team submitted a request to play the University of Chicago Maroons, they never received a reply. (Department of Special Collections, Chicago Public Library.)

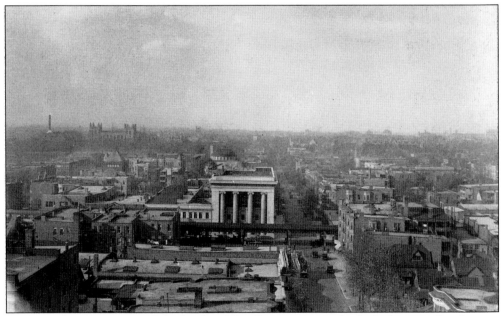

By the early 1920s, most of the land in Woodlawn was completely built up, and a thriving commercial mix dominated 63rd Street along the Elevated route. Looking north across the 63rd Street Elevated, the towers of Harper Memorial Library on the University of Chicago campus are visible. (Department of Special Collections, Chicago Public Library.)

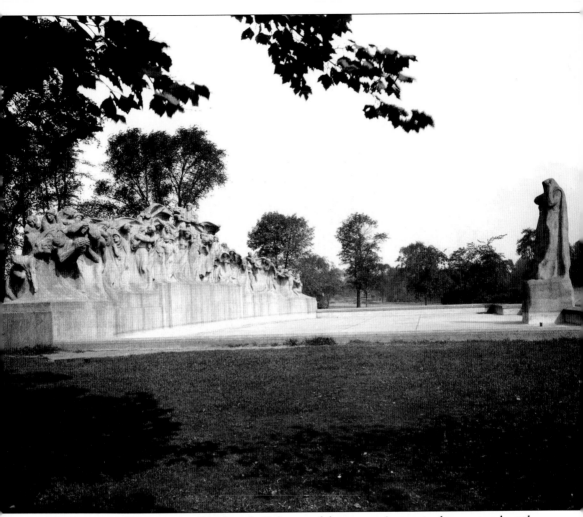

The Fountain of Time, executed by Lorado Taft, one of the country's great sculptors, stands at the western end of the Midway Plaisance at the entrance to Washington Park. The statue was built to commemorate 100 years of peace between England and the United States in 1914, although the piece itself was not finished until 1922. With its depiction of the breadth of humanity, offset by the seemingly brooding hooded figure that looks towards the main sculpture, this piece is perhaps one of the most introspective in the Chicago Park District. Lorado Taft was an instructor at the university and made his home nearby at 60th and Ingleside, along the Midway itself. Clarence Darrow, the renowned jurist, made his home for over 30 years at the Plaisance Hotel, located at the other end of the Midway at 60th and Stony Island Avenue. (Department of Special Collections, Chicago Public Library.)

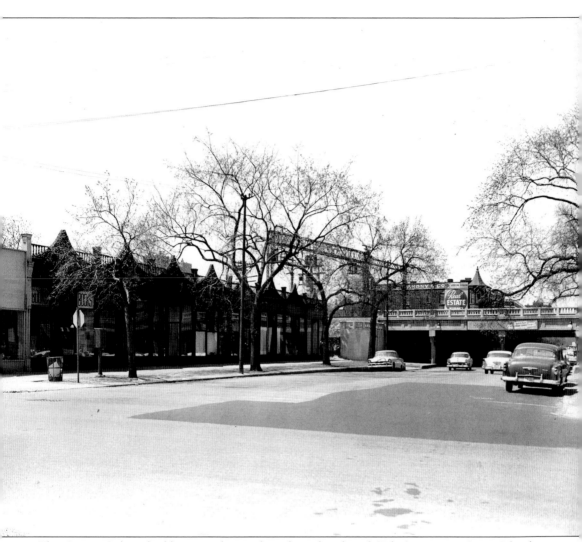

The Artists Colony buildings on the south and north sides of 57th Street near Stony Island were originally built as cheap studios for artists and other bohemians associated with the World's Fair of 1893. As such, they contained few additional amenities beyond pot-bellied stoves and somewhat makeshift plumbing. Regardless of this fact, they were extremely affordable spaces for artists who worked in a variety of mediums ranging from the English language to watercolors. In the 1920s, the Artists Colony buildings provided temporary solace to writers like Carl Sandburg, James T. Farrell, and Theodore Dreiser. By the 1950s many of the writers had left, but there were a significant number of artisans who still rented space in the building, including several used book stores, a Swedish crafts store, and a pet store. While shop vacancy had been on the rise throughout the decade, the death knell for the buildings came when the city made 57th Street a one-way street going east from the IC tracks (this photograph was taken in early 1957, hence the two-way pattern). Tenants protested to the city, but to no avail. The buildings were shuttered in 1962, and demolished shortly thereafter. Several decades later, a black sorority headquarters was built on the north side of the street, and a University of Chicago dormitory on the south side. (Department of Special Collections, Chicago Public Library.)

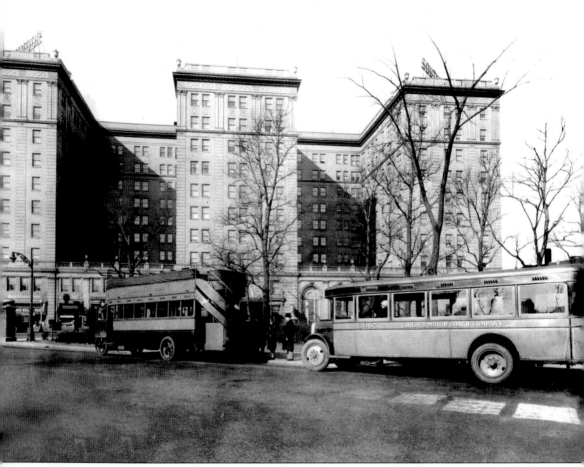

The Hotel Southmoor at 67th and Stony Island Avenues was Woodlawn's answer to Hyde Park's fantastic run of apartment building that commenced in the early 1920s. Finished in 1928, the Southmoor featured views of Jackson Park and nightly performances by the Southmoor String Ensemble. The manager of the hotel, Robert E. Clarke, was affiliated with the Victor Record Company, and was able to secure several highly regarded dance bands to perform on a nightly basis in the Venetian Dining Room. While the Southmoor did not require leases, hotel rooms with a private bath were available for $65 a month. Even though the Southmoor fell into receivership during the Depression, business picked up again after World War II. Regrettably, the Southmoor suffered from poor management, and the rapidly deteriorating Woodlawn community could not support such an enormous hotel without significant tourist trade and the building was later razed. During the Southmoor's history, it was owned for a time by Mahalia Jackson, and was later under the control of the Blackstone Rangers, one of the most well known gangs operating in Woodlawn. (Department of Special Collections, Chicago Public Library.)

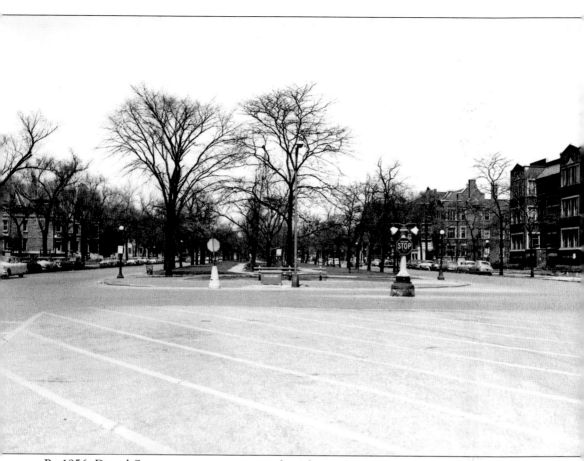

By 1956, Drexel Square was an entry point for African Americans trying to move away from the old Black Belt ghetto that had reached down to Hyde Park from the north and west. While the homes along the square remained largely owned by whites, the large apartment buildings along Drexel Avenue quickly became full with lower-income African Americans and a few poorer white families. Northwest Hyde Park quickly became overwhelmingly African American soon after the 1948 *Stanley v. Kramer* Supreme Court decision declared the use of restrictive covenants was unconstitutional. Northwest Hyde Park, under the direction of several community leaders including one Victor Towns, mobilized to meet with new arrivals to the area and to talk about setting common goals and aspirations for their part of Hyde Park. The experience of northwest Hyde Park was much less problematic than the problems both community members and the University of Chicago would face when dealing with the question of what would happen to southwest Hyde Park during the urban renewal period. (Department of Special Collections, Chicago Public Library.)

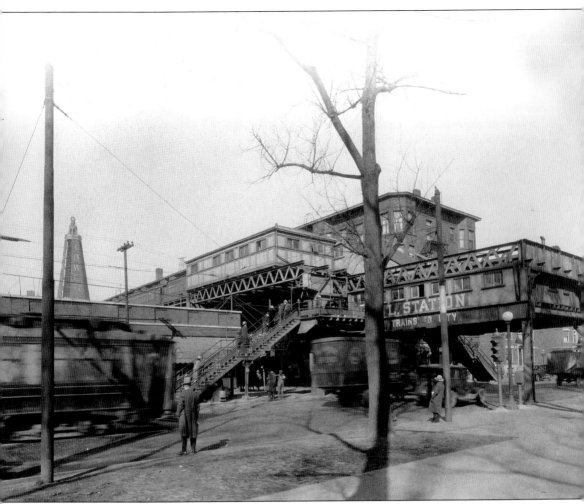

An earlier photograph of 63rd and Stony Island from the 1920s shows the Stony Island trolley along with the Elevated line. The *Hyde Park Herald* of the time reported that numerous groups of homeless men would congregate around the entrance to the El and ask people for their transfers. Receiving little or no support from those passing by, the would often resort to "roaming about the north end of Jackson Park, sometimes attempting to form their own version of Coxey's Army, with grand plans of marching on City Hall." (Department of Special Collections, Chicago Public Library.)

The Gladstone Hotel also remained a solvent operation until the early 1950s, when it began to find that its main customer base was no longer tourists, but rather a more undesirable group of individuals that tended towards not paying the bills before leaving. The situation continued to be more hopeless for the hotel until it finally closed its doors in the early 1960s. (Department of Special Collections, Chicago Public Library.)

This pumping station at 68th and Olgesby was the culmination of years of lobbying by both the Hyde Park and Woodlawn communities. Since the village's inception in 1853, the trustees in Hyde Park had been attempting to secure a more modern pumping system, but they were unable to raise the necessary funds. Finally in 1911, the City of Chicago finally acquiesced and built the modern facility pictured here. (Department of Special Collections, Chicago Public Library.)

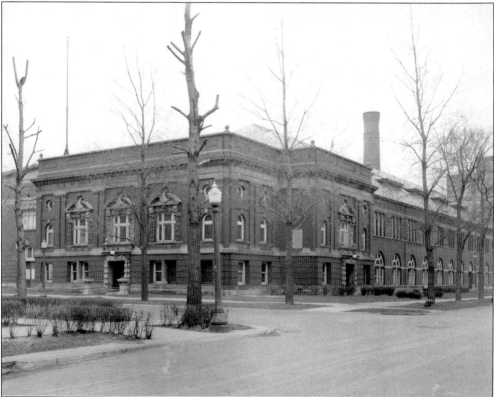

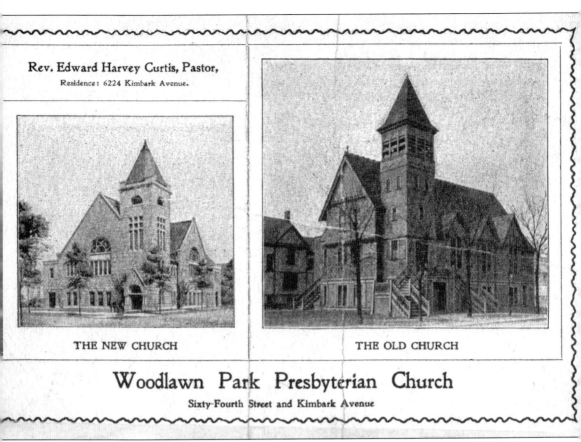

Rev. Edward Harvey Curtis, Pastor,
Residence: 6224 Kimbark Avenue.

THE NEW CHURCH

THE OLD CHURCH

Woodlawn Park Presbyterian Church
Sixty-Fourth Street and Kimbark Avenue

Along with extensive building for commercial and residential life, the people of Woodlawn were quick to build numerous facilities for worship. By 1900, churches in the area included Holy Cross Roman Catholic Church, the Woodlawn Baptist Church, Christ Episcopal Church, the Woodlawn United Presbyterian Church, St. Paul's on the Midway, St. Cyril's Roman Catholic Church, the Woodlawn Church of the Nazarene, St. Stefan's Danish Evangelical Lutheran Church, and Langley Avenue Methodist Episcopal Church. The postcard here shows the old and new buildings of the Woodlawn Park Presbyterian Church, the oldest religious organization in Woodlawn. The first structure lasted until 1900, until the present edifice was constructed. While many local residents of that part of Woodlawn were concerned about the influx of hotel and commercial facilities, they expressed great adoration for the presence of the new church. (Department of Special Collections, Chicago Public Library.)

No late-19th-century American community would be complete without sufficient space for the many voluntary organizations and clubs that were endemic to many areas. The Woodlawn Masonic Temple, finished in 1906, was one such building. The Masons were proud to announce at the building's dedication that "it is one of the busiest and most inviting places in Woodlawn." (Department of Special Collections, Chicago Public Library.)

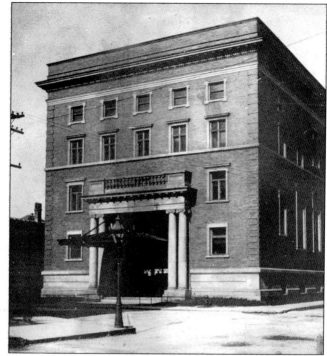

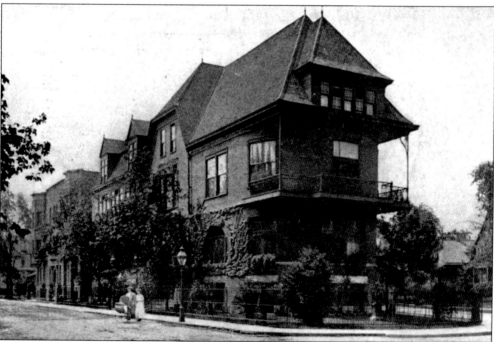

Another such club was the Woodlawn Park Club, founded by a group of socially minded Woodlawnites in 1886. Located at Woodlawn and 64th Street, the building met with an untimely end in a massive fire in 1919. While the fire was rather unfortunate, it brought the community together, and they eventually convinced the city to install a new fire station at 62nd and Dorchester Avenue. (Department of Special Collections, Chicago Public Library.)

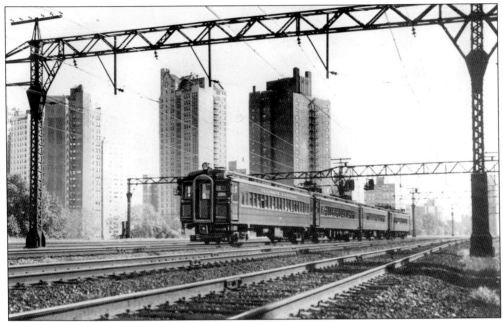

The Illinois Central continued to increase service to Hyde Park throughout the late 1920s, adding up to 300 trains daily during some periods of service. The tall apartment buildings in East Hyde Park were built to take advantage of their proximity to the lakefront, even though some older residents began to complain about overcrowding in the area as early as 1921. (Department of Special Collections, Chicago Public Library.)

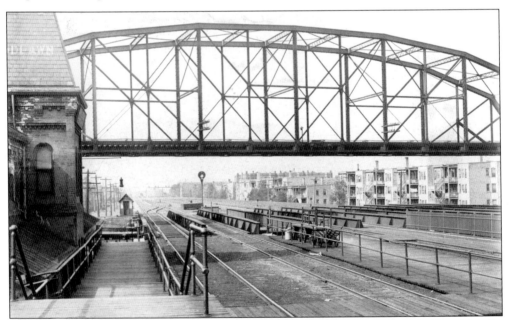

The old Woodlawn train station in this photograph was shortly going to be replaced by the modern Illinois Central building going up immediately behind it. Once again, the Elevated tracks are going over the IC right-of-way to terminate service at Stony Island Avenue. (Department of Special Collections, Chicago Public Library.)

The construction of the nine-story Illinois Central terminal and office building commenced in 1920 and was finished in 1921. The Woodlawn stop would remain a popular train stop for many decades, as one could board a train for Miami, New York, and other destinations at the terminal. Along with the 12th Street station, the Woodlawn stop served the thousands of African-American migrants from the South who were traveling to Chicago to meet family, and particularly after World War II, to stay and find work. (Department of Special Collections, Chicago Public Library.)

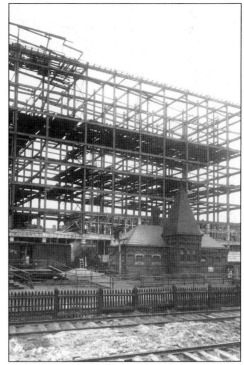

This shot from the early 1950s showcases the mass transit options available to South Side residents. The buses shown here (which replaced streetcar lines) moved people on Stony Island and 63rd Street, while the Elevated extended north to the loop and contiued north to Howard Street in Rogers Park. Visible on the west side of the street are the Hotel Parkland and the Greyhound bus station. (Department of Special Collections, Chicago Public Library and Sherwin Murphy.)

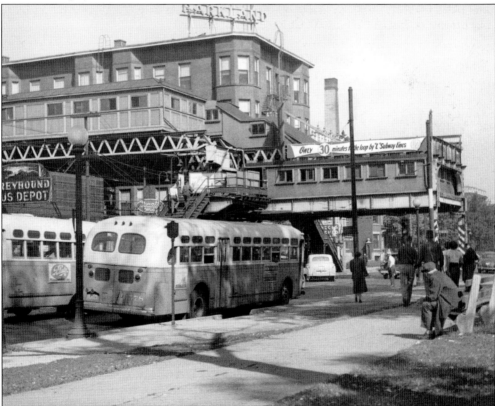

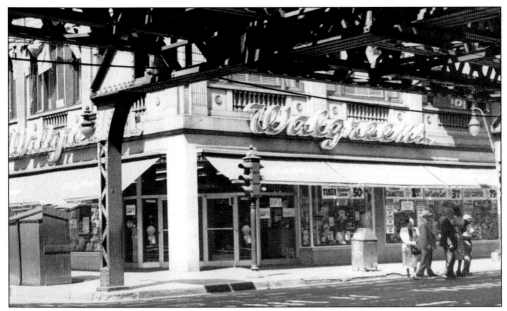

The first Walgreens store was originally located at 39th and Cottage Grove, and the rest of the South Side inevitably followed as an area for future store location and expansion. In addition to two stores in Hyde Park, there were several Walgreens on 63rd Street, including this one at 63rd and Woodlawn. (Department of Special Collections, Chicago Public Library and Lil and Al Bloom.)

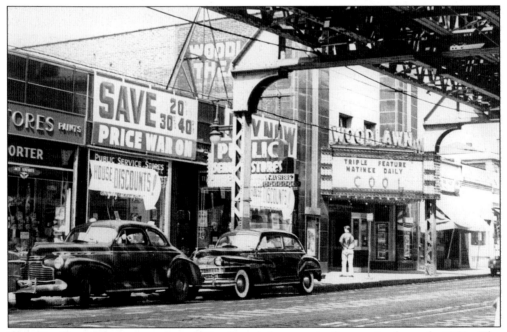

The Woodlawn Theater was one of Woodlawn's four movie theaters in the early 1950s. The theater's capacity was rather small, and competition from television and surrounding theaters spelled the end for this theater in the late 1950s. By the late 1960s, the last movie theater in Woodlawn had closed its doors. (Department of Special Collections, Chicago Public Library.)

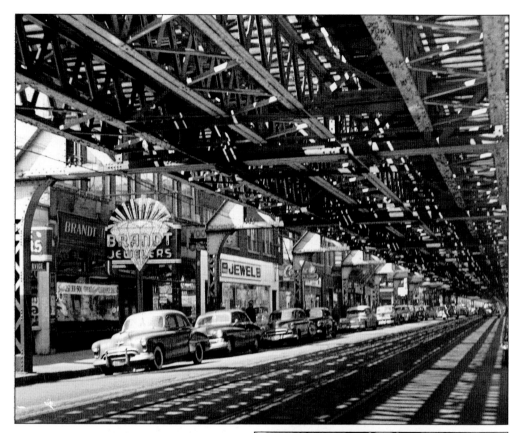

By the early 1950s, Woodlawn was trying to grapple with problems associated with overcrowding and blight in the community, although it would be hard to tell from this photograph taken at 63rd and Kimbark. This particular stretch of 63rd Street was home to half a dozen jewelry stores even as late as the late 1950s. (Department of Special Collections, Chicago Public Library and Lil and Al Bloom.)

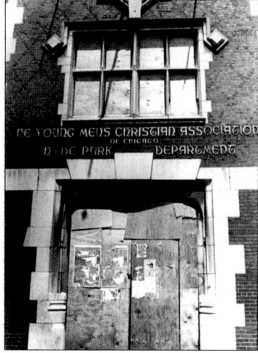

The once venerable YMCA building on the northeast corner of 53rd and Dorchester awaits demolition by the Community Conservation Board in this late 1982 photograph. Several buyers had expressed interest in the property, but only if the city would first raze the building. Local residents also filed complaints stating that transients were setting fires inside the structure in an attempt to stay warm. By the middle of 1983, the building was gone. (Chicago Maroon.)

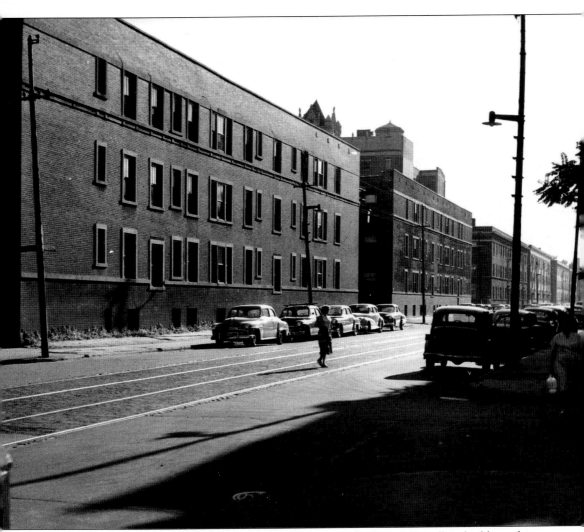

Sixty-first Street in the early 1950s was primarily lined with three-story walkup buildings dating from the 1910s. While the streetcars had been removed from 61st Street in 1948, the tracks had not yet been removed. This street was also fast becoming a complicated area for the university, as most of Woodlawn was beginning to head down the long road of racial succession and socioeconomic change that was characteristic of numerous Chicago neighborhoods after World War II. The university was able to purchase a great deal of the land between 60th and 61st Street during the last decade of the 19th century, but many of the remaining properties had not been properly maintained, or even worse, had been subjected to illegal conversions by opportunistic landlords. By the late 1950s, many faculty members and students who had lived for decades found the changing neighborhood increasingly less collegiate and had moved back into Hyde Park proper. (Department of Special Collections, Chicago Public Library and Sherwin Murphy.)

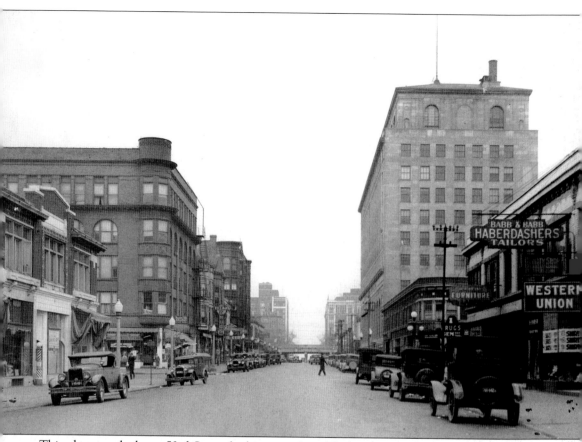

This photograph shows 53rd Street looking east from Blackstone Avenue in 1930. The Hyde Park Bank building is the dominating structure on the south side of the street next to Lake Park Avenue. While the lobby of the building is quite understated, bank patrons would walk up a marble staircase into the bank lobby, which features high ceilings and a variety of other flourishes. Upon its completion, the *Hyde Park Herald* proclaimed that the new bank building would "let Hyde Park assume the mantle from the Loop as the new headquarters for professional and courtesy banking." While the bank occupied part of the building, the rest of the suites were primarily occupied by various health professionals and offices for lawyers. The retail heterogeneity that continues to characterize 53rd Street today is visible, as one can see signs advertising laundry cleaners, a bakery, a drug store, and a photography studio. (Department of Special Collections, Chicago Public Library and John C. Spray.)

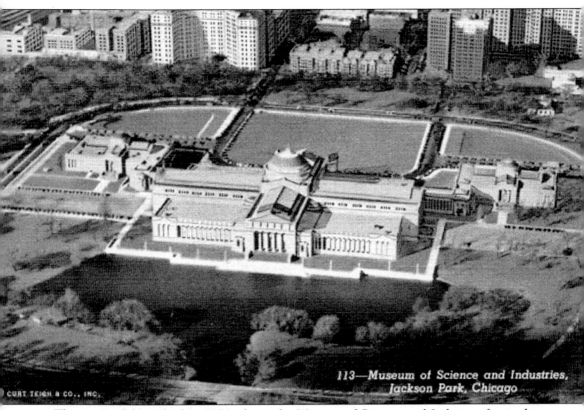

113—Museum of Science and Industries, Jackson Park, Chicago

This postcard from the late 1950s shows the Museum of Science and Industry after its long transformation from the Fine Arts Building of the World's Fair into a modernized and structurally sound building. Directly ahead of the museum's rotunda along 56th Street stand several walkup apartment buildings that were later replaced by a rather unimpressive 40-story luxury condominium building. Immediately west of those apartment buildings is the Windermere East and West Hotels. While the Windermere East Hotel was a more modern structure designed for more sophisticated urban living, the Windermere West was quite rundown by the middle 1950s and was subsequently torn down by the end of the decade. Perhaps the most famous resident of the old Windermere West was Edna Ferber, the American novelist responsible for penning *So Big* and *Giant*. (Private Collection.)

Two

THE SCENE CHANGES
HYDE PARK RESPONDS
TO NEIGHBORHOOD DETERIORATION

By the early 1930s, there was a growing concern about the changing demographic makeup of Hyde Park, both from the University of Chicago and local community groups. Numerous studies were commissioned to examine the increasing problems of juvenile delinquency and the emergence of the phenomenon of illegally converted units in the walkup apartment buildings of central Hyde Park and older single-family homes. While many in the community were concerned about the continued viability of an integrated community in light of an increased African-American population (particularly after 1948, when restrictive covenants were declared unconstitutional), other groups of residents and the University of Chicago were concerned with the safety of the campus and its fixed properties, including a physical plant that was valued at many millions of dollars. Early responses in the community included the formation of the Hyde Park-Kenwood Community Conference in 1949 and the South East Chicago Commission in 1952, which was sponsored by the university and members of the community.

Various pieces of legislation passed at the federal and state level made the possibility of receiving large sums of money from the government for community conservation a reality for Hyde Park. By 1955, the University of Chicago and the South East Commission were collaborating on a plan that would remove areas of blight and "obsolescence" from the area, with a particular eye towards the rapidly deteriorating area around 55th and Lake Park Avenues. While at times it seemed as if the federal government would not come through with adequate funds for purchasing the questionable properties and subsequent redevelopment in a timely manner, Chancellor Lawrence Kimpton and Julian Levi, the head of the South East Chicago Commission, made several trips to Washington D.C. to meet with President Eisenhower on this pressing question of great importance. This is not to say that there was little or no dissent within the community regarding the proposed plan. On the contrary, several groups, including the Hyde Park-Kenwood Community Conference and the Archdiocese of Chicago led by Monsignor Egan, took exception to the plan, particularly due to the fact that the plan did not include any provisions for public housing. Eventually the plan made a provisional agreement for several hundred public housing units, which was later reduced to 60 units of public housing solely for the elderly. After the passage of the final urban renewal plan in 1958 by the city council, the plan proceeded with renewed vigor.

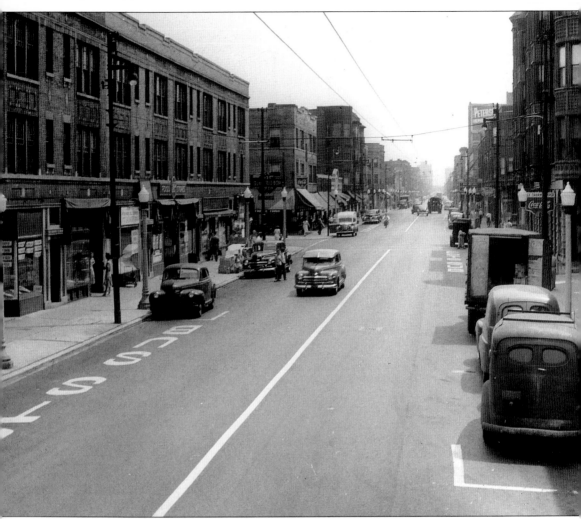

By the time of this photo, this section of 55th Street was alternately considered a "gulch" by some and a convenient place to shop and imbibe spirits by others. While this section of land was not included in the formal Hyde Park Urban Renewal Plan (parts "A" or "B"), the university became extremely interested in purchasing some of the properties on the south side of 55th Street between Cottage Grove and Greenwood Avenues. Some of the properties had been owned by the university for many decades (before the area saw an influx of poorer black and white families), but still other properties were owned by landlords who saw the potential for a great deal of profit by dividing up some of the larger buildings and increasing the rents. The situation in Southwest Hyde Park, while not the subject of any official policy until the 1950s, was of some concern to some members of the board of trustees decades before, most notable Harold H. Swift. In a note to a university administrator dated May 18, 1925, Swift expressed concern about the area between 55th and 59th close to campus, remarking that "I know we are going to be sorry if we don't do something about reclaiming the property from 55th to 59th between Ellis and Cottage Grove. If we don't look out, in 10 years from now we will not understand why we didn't do something about it. . . ." (Chicago Transit Authority.)

This photograph taken near 55th and Cottage Grove shows the newly installed CTA buses, which replaced the old trolleys that ran down the center of Hyde Park's main retail area. The retail environment was similar to that of Woodlawn, with primarily two- and three-story mixed use buildings forming the bulk of the built environment all the way east to Lake Park Avenue. (Chicago Transit Authority.)

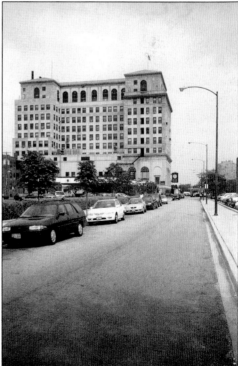

There are only a few reminders in the area that this small side street was once in fact Lake Park Avenue before urban renewal commenced. The buildings to the east of the former Lake Park Avenue were all condemned and demolished, and the street was widened and moved over to run flush against the IC tracks. (Max Grinnell.)

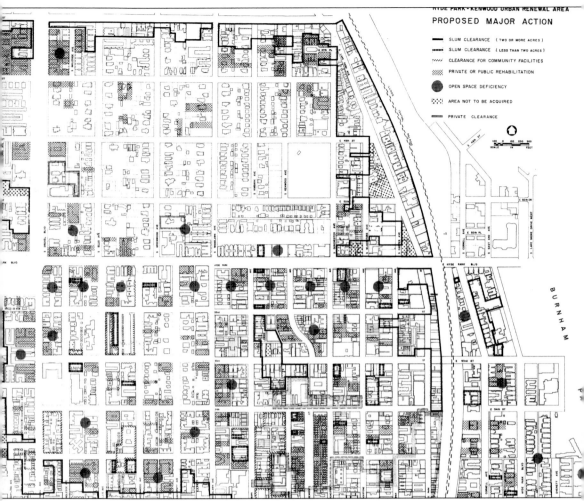

PROPOSED MAJOR ACTION

- SLUM CLEARANCE (TWO OR MORE ACRES)
- SLUM CLEARANCE (LESS THAN TWO ACRES)
- CLEARANCE FOR COMMUNITY FACILITIES
- PRIVATE OR PUBLIC REHABILITATION
- OPEN SPACE DEFICIENCY
- AREA NOT TO BE ACQUIRED
- PRIVATE CLEARANCE

This plan for the disposition of the Hyde Park Renewal program gives some indication of the massive problem of blight that the community faced by the early 1950s. Besides the retail areas that seemed to be becoming obsolescent along Lake Park Avenue, many of the older apartments that occupied the upper floors of the walkup buildings along 55th Street had become havens for a certain class of low-grade criminals who congregated around some of the seedier taverns near 55th and Lake Park Avenue. The initial urban renewal plan was drawn up by the Planning Unit of the University of Chicago, under the direction of Jack Meltzer and underwritten by funds from the Field Foundation. While this map gives some indication of the formal boundaries of the urban renewal plan, it does not include hundreds of buildings that were later demolished as part of the spot clearance that the Land Clearance Commission and Community Conservation Board specialized in. (Map Collection, The University of Chicago Library.)

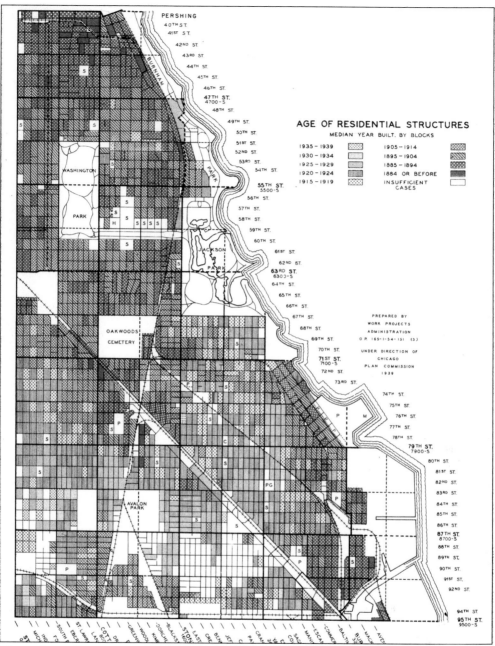

AGE OF RESIDENTIAL STRUCTURES

MEDIAN YEAR BUILT, BY BLOCKS

1935 - 1939		1905 - 1914	
1930 - 1934		1895 - 1904	
1925 - 1929		1885 - 1894	
1920 - 1924		1884 OR BEFORE	
1915 - 1919		INSUFFICIENT CASES	

PREPARED BY
WORK PROJECTS
ADMINISTRATION
O.P. 165-1-54-151 (3)
UNDER DIRECTION OF
CHICAGO
PLAN COMMISSION
1939

This rather telling map, produced in 1939 by the Works Progress Administration, shows the lack of new construction within most of the South Side since the early 1920s. While many of the buildings were not in fact dilapidated by this point, many of them soon would be owing to a lack of available materials during World War II and shoddy maintenance, coupled with poor or non-existent upkeep. In many areas that were experiencing racial transition, landlords would often neglect buildings and rent to African Americans at higher rates than those rents charged to the previous white tenants. Hyde Park and Woodlawn both had their share of three and four-decade-old structures in 1939, and some patterns of blight would soon manifest themselves (Map Collection, The University of Chicago Library.)

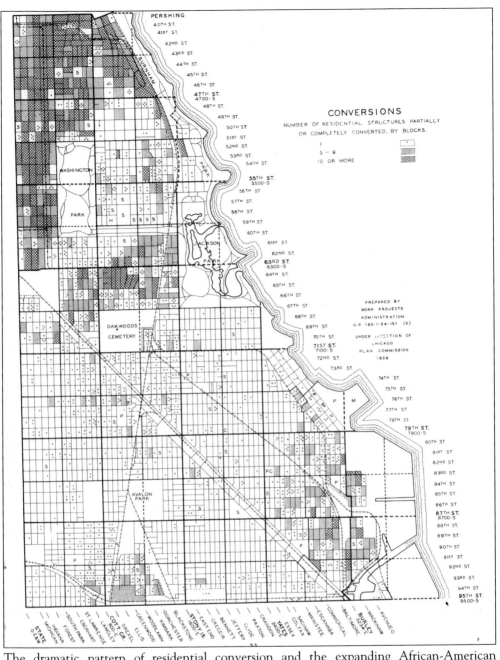

The dramatic pattern of residential conversion and the expanding African-American population of Chicago is evident in this 1939 map. Hyde Park had some small areas of conversion activity centered around 55th Street, but nothing like the situation in Grand Boulevard (north of Washington Park) or in the Washington Park community immediately west of the park. The Black Belt of Chicago abruptly ended at Cottage Grove Avenue, but after the lifting of the restrictive covenants, many African Americans moved into Hyde Park seeking (understandably) better living quarters and the opportunity to move out of housing that in many cases did not contain indoor plumbing or even a modicum of modern conveniences. (Map Collection, The University of Chicago Library.)

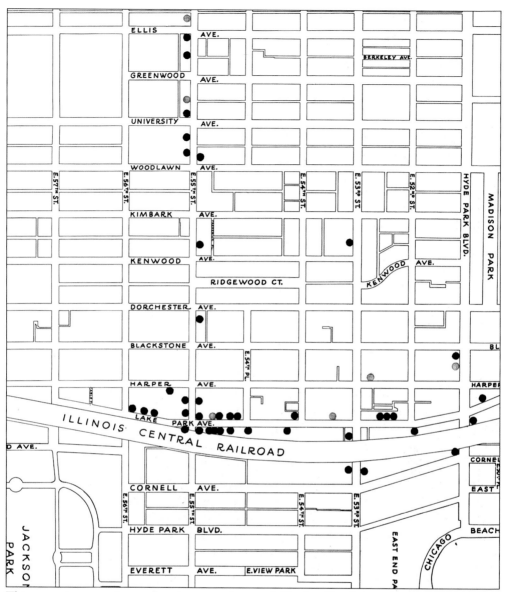

This mapping exercise, under the supervision of Charles Hendry at the George Williams College, sought to document the various places of amusement in Hyde Park. While opportunities for movie-going and live theater were quite abundant in Hyde Park, 55th Street provided much of the area's entertainment options in 1935. Gray dots indicate the presence of a movie theater and the darker black dots indicate bars or taverns, of which there are quite a few. There were relatively few complaints about the bars in the area during this time, except for a series of rabid editorials in the *Hyde Park Herald* calling for local option votes to declare certain precincts in the ward completely dry. One type of amusement that was not listed on this document was the presence of gambling houses in Hyde Park. While this map does not feature such listings, Ernest Burgess, the well-known sociologist, had done his own fieldwork to identify the locations of such activities, eventually concluding that most of these illegal activities took place at newsstands and in the back rooms of more than several bars along Lake Park Avenue. (Map Collection, The University of Chicago Library.)

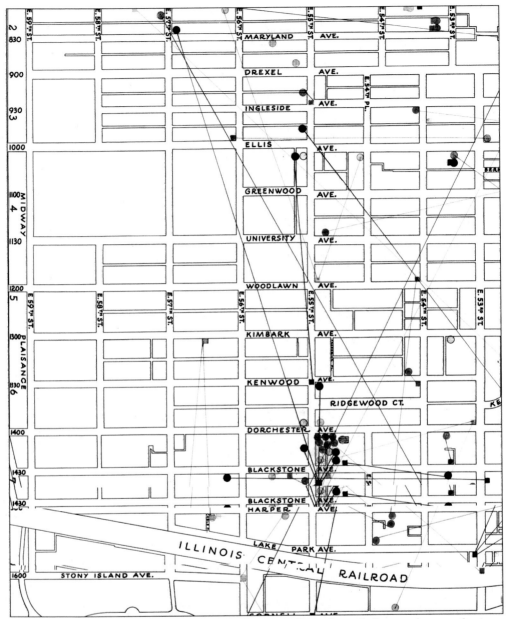

Another map produced by the George Williams College showed the incidences of crimes committed by juveniles living in Hyde Park and their location. While only an incomplete legend exists for the map, crimes that are listed include assault, breaking windows, burglary, fighting, use of rifles, sex offenses (this is only vaguely defined), selling papers without a permit, and the crime of being homeless. The nearby Hyde Park Police Station at 52nd and Lake Park had a juvenile officer to handle such cases, but by the mid-1930s, his workload had tripled within several years. The theft of bikes was considered one of the most heinous crimes in the community and was frequently practiced by several members of the self-proclaimed "Dorchester Avenue Gang." There was still great concern for the welfare of these young men, as the Hyde Park Neighborhood Club initiated extensive programs for teenagers, even after several of their number vandalized part of the club. (Map Collection, The University of Chicago Library.)

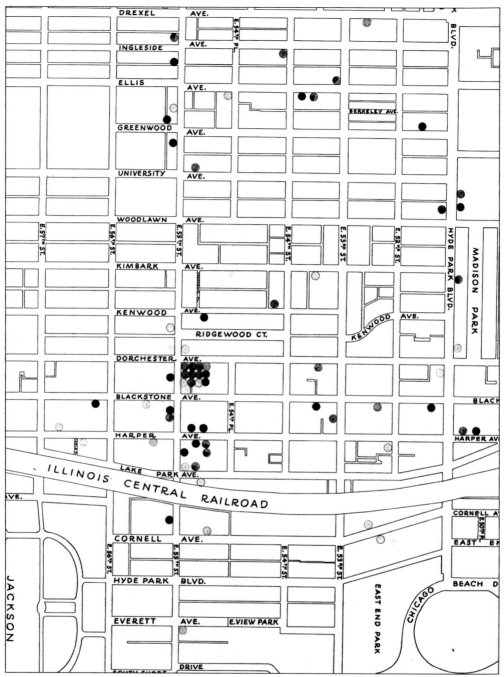

This final map in the George Williams series mapped the location of Hyde Park's juvenile delinquents. As previously mentioned, there appeared to be a large concentration in the buildings around 55th and Dorchester. Little is known about the buildings at this immediate corner, except that there were several large walkup apartment buildings, where some of these young miscreants lived together without any supervision in a sort of a rogue's orphanage. There were other significant concentrations of juvenile delinquents throughout the community, but none as dense or spatially concentrated as this one. (Map Collection, The University of Chicago Library.)

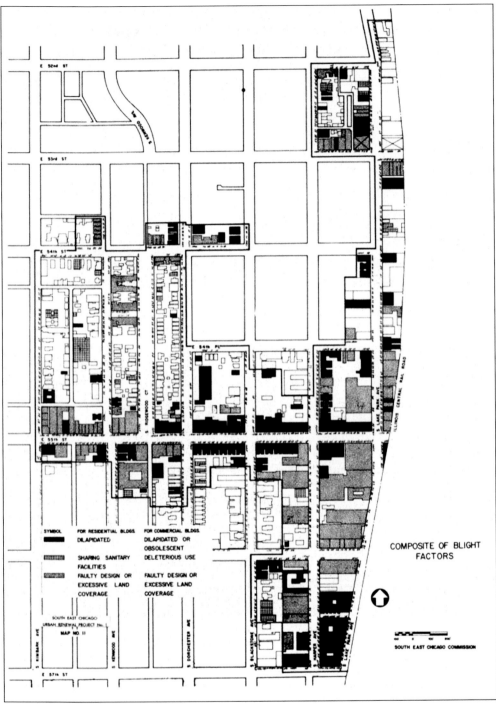

This composite map of blight was produced in 1954 for the South East Chicago Commission's preliminary report on the urban renewal proposal. Lake Park Avenue was a particularly blighted area, with almost every structure on the east side of the street showing some signs of deterioration. While demolition of the properties began in the middle of the 1950s, the structures would not all be entirely removed until the early 1960s. (South East Chicago Commission.)

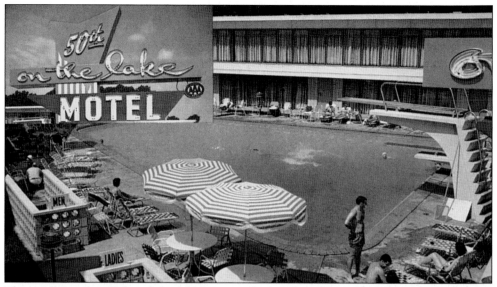

This small motel at 50th and the lakefront was the last flourishing of hotels built in Hyde Park. Catering primarily to automobile bound trade, the hotel had a car park and other amenities. The hotel was remodeled several times and is now part of the Ramada Inn chain. (Private Collection.)

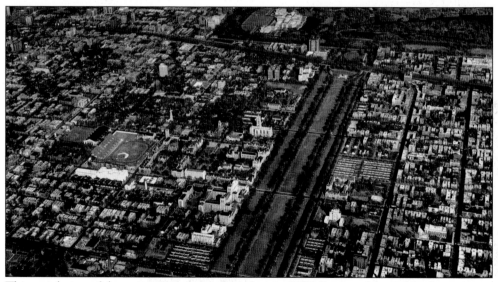

This aerial view of the university campus was taken in 1950. By now, the pre-fabs for returning veterans had been built along the Midway (on the site now occupied by the Law School), Dudley Field (behind Ida Noyes Hall), and near 59th and Cottage Grove. The housing needs continued to grow as members of the administration expressed their concerns about competing with peer institutions for undergraduate and graduate students alike. Given the changing racial and economic composition of both Woodlawn and Hyde Park, it was becoming harder to attract students and faculty to the area, and some faculty had already departed for less embattled locations. As new construction of dorms was usually prohibitively expensive (although this matter was debated by the trustees), the university continued their extensive real estate purchases throughout the decades, with continued heavy investments throughout Woodlawn, north of 61st Street and Southwest Hyde Park. (Private Collection.)

Robert Maynard Hutchins, "The Boy Wonder," became president of the University of Chicago in 1929, at the tender, yet experienced age of 30. In his first year alone, he made over 200 speeches around the country about the importance of higher education and its place in American society. Back on campus, some members of the faculty grumbled about the fact that he seemed to make academic appointments by fiat, rather than consulting the department heads. Soon after his arrival, he brought the late Mortimer Adler from Columbia (who later wrote that he composed 77 pages of his dissertation in a single day) and Richard McKeon to the philosophy department. Despite his passionate interest in the world of higher education, he seemed somewhat oblivious to the problems that the university was faced with in light of the changing makeup of the surrounding area. President Hutchins received several requests from community groups to appear at their meetings, but when he did show up, he rarely stayed longer than a few minutes. One apocryphal story about Hutchins' general lack of interest in community affairs is related to an appearance at his office by Louis Wirth, one of the sociologists who had done some work in examining the area. After he made a few potential suggestions to Hutchins that might benefit the university community, Hutchins abruptly replied, "You teach, and I'll administer." (Private Collection.)

Another part of the Conservation study sponsored by the Metropolitan Housing and Planning Council had an extended section on the frequent code violations that were becoming endemic to the South Side. The dumping of coal on the sidewalk seems rather noxious, while the illegal parking near a fire hydrant and the even more unbelievable transgression of blocking a driveway seem rather trivial today. (Metropolitan Planning Council.)

VIOLATIONS

Illegal parking by fire hydrant
5600 block on Blackstone Avenue

Typical coal delivery
5600 block on Blackstone Avenue

Illegal parking blocking driveway at
5620 Blackstone Avenue

Another service of the Hyde Park Neighborhood Club in the past few decades has been to provide recreational activities for the elderly in the community. Here are a few visitors to the club visiting the craft room and watching as several people work on their projects. (Hyde Park Neighborhood Club and Nancy Hays.)

In this undated photograph (most likely from the early 1950s), several children gather at the Hyde Park Neighborhood Club. By this point in the club's history, it had been located all over Hyde Park, including one stint at the old Illinois Central station on 57th Street. In 1911, the club moved to new headquarters at 5435 South Lake Park Avenue, which, based on observations and interviews, seemed to be the center of the juvenile delinquency problem in Hyde Park. By the early 1920s, the club moved to 5513 Kenwood, setting up their operations in an old building built for the World's Fair. Members of the university community continued their interest in the club, with several students from the School of Social Service Administration electing to work at the club as part of their field placement. The club later moved to rather luxurious quarters at the old home of the Hyde Park Congregational Church at the northwest corner of 56th and Dorchester. Finally in 1951, the Hyde Park Neighborhood Club acquired the land for its current building at 55th and Kenwood. (Hyde Park Neighborhood Club.)

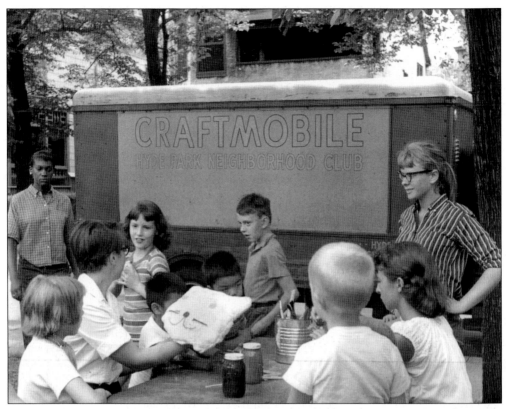

One of the most popular programs that the club has provided over the years is its Craftsmobile. During the summer months, the Craftsmobile travels around Hyde Park, making stops to allow young people the opportunity to create their own projects. The program remains a great success to this day. (Hyde Park Neighborhood Club and Nancy Hays.)

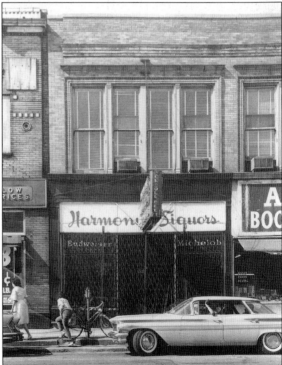

By early 1962, urban renewal had begun to catch up with this part of 55th Street near Kenwood Avenue. As this building was scheduled for demolition, the Neighborhood Club was granted permission to use the building until demolition as a study center for neighborhood children who might need assistance with their homework. (Hyde Park Neighborhood Club and Nancy Hays.)

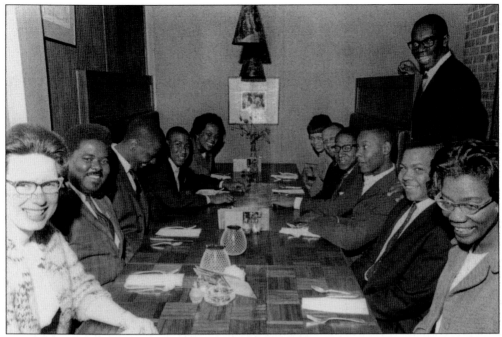

In this 1967 photograph, the staff members of the Hyde Park Neighborhood Club celebrated Junior Officials Day. At the far left are Pat James and Chuck Jones. On the far right are program director Norma Pendleton and William Iverson (standing), who at the time was the chair of the Neighborhood Club. (Hyde Park Neighborhood Club.)

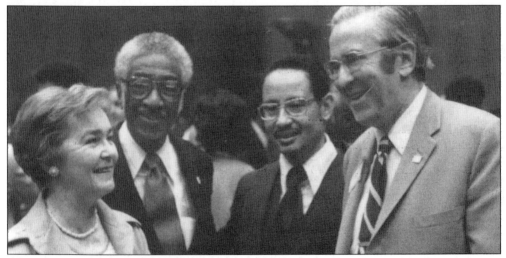

The Hyde Park Neighborhood Club has always had its share of strong allies in the community, and this photograph demonstrates some of that connection. Here Ed Field, the then president of the Neighborhood Club, meets with the late Ralph Metcalfe (second from the left), the noted politician in Washington D.C. From its inception in 1909, many members of Hyde Park and the University of Chicago were concerned with providing young people throughout the community with a safe place to play and engage in supervised recreational activities. While the club has moved for a variety of reasons during its 90-year history, the club has been at 5480 South Kenwood since 1951. (Hyde Park Neighborhood Club.)

Cleaning up the building on 55th Street proved to be a formidable task for the volunteers from the Hyde Park Neighborhood Club, but they were able to finish in sufficient time to allow students to use the space several months later. (Hyde Park Neighborhood Club.)

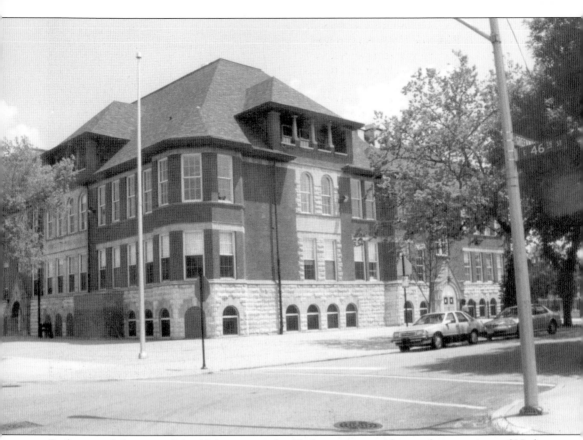

Built around the turn of the 19th century, the Shakespeare served several generations of Hyde Park and Kenwood residents before being shuttered in the early 1980s. Distinguished alumni of the 1930s included both Mel Torme (before he acquired the nickname he so despised, "The Velvet Fog") and Steve Allen of the *Tonight Show*. By the 1980s, the building saw its population base move away from the area, and the school was shuttered. The most activity the building saw in the early 1990s was as a shooting location for the Harrison Ford film *The Fugitive*. A fresh breath of air blew into the school when both the Ariel Academy and the North Kenwood-Oakland Charter School moved into the renovated structure in the late 1990s. The Ariel Academy places a premium on developing the business acumen of young people, while the NKO Charter School is fortunate to have the kind support of the University of Chicago. Given the recent population increase in the Kenwood area, it is anticipated that both institutions will remain successful and viable. (Joon Park.)

Similar to the style of many other apartment hotels in Hyde Park, the Hotel Aragon was built in 1922. Like many other apartment hotels in Hyde Park, the building experienced a vacancy rate of close to 30 percent by the middle 1960s. This did not comfort the residents of the Aragon much, as the Catholic Theological Union purchased the building, and they were subsequently forced to move out. (Private Collection.)

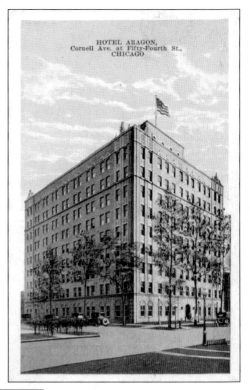

This photograph was taken to illustrate the blighted conditions under which many young people lived in around central Hyde Park in the early 1950s. The volume it was taken for was a comprehensive report on community conservation prepared by the Metropolitan Housing and Planning Council of Chicago, the predecessor organization to the current Metropolitan Planning Council. (Metropolitan Planning Council.)

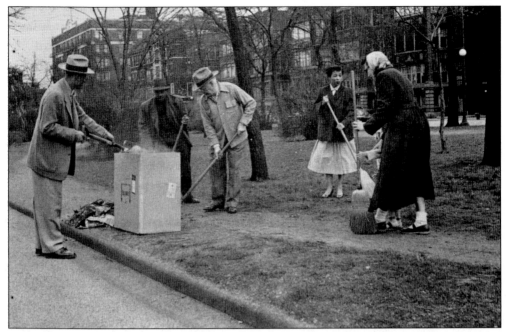

This photograph comes from a booklet produced as part of study done by the Department of Education at the university. Professor Herbert Thelen oversaw the study, which endeavored to examine the conditions that contributed to effective community action and organization. The study area centered around the Drexel Square Area (renamed "Sycamore Court" for the study), and was concerned with providing a way for newer residents (mostly African American) and older residents to work together effectively. (Herbert Thelen.)

From the same booklet, this photograph shows the diversity of people that lived in the Drexel Square area in 1954. Participants in the project found that the study was in fact quite helpful, and contributed to creating a climate of understanding and trust, rather than allowing people to become distrustful and apathetic. (Herbert Thelen.)

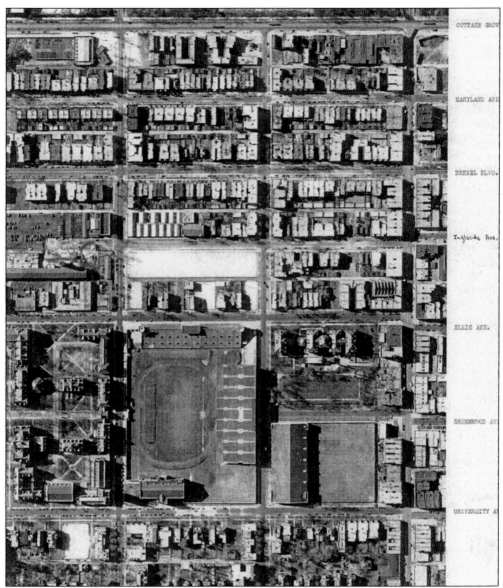

This aerial shot of the area (bottom of photograph) from 55th to 58th Streets between Cottage Grove Avenue (top of photograph) and Woodlawn Avenue shows the extent of the land coverage in southwest Hyde Park. Near the lower left-hand corner of the photograph is the Main Quadrangle of the university, directly south of Stagg Field along 57th Street. The west side of Ingleside Avenue between 56th and 57th Streets was used for the Botany Greenhouses, a purchase the university had made several decades earlier. Fifteen years later, the entire area between 55th and 56th Streets between Cottage Grove and Ellis Avenue would be cleared by the South West Hyde Park Redevelopment Corporation, with the exception of four university-owned buildings, which were used for graduate student housing. Immediately north of Stagg Field is the Chicago Home for Incurables, which was later purchased by the university. While most of the buildings in the block were demolished in order to preserve the "character of the university," the main building of the Home at 56th and Ellis was retained for use as the University of Chicago police headquarters. (Map Collection, The University of Chicago.)

81

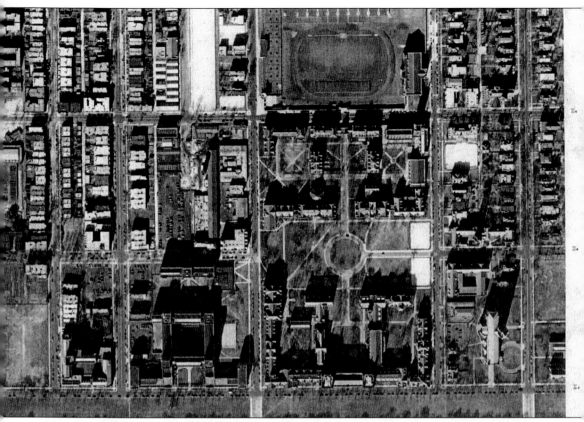

This detailed photograph of South Central Hyde Park shows the university campus in greater detail, including the blank spot left at the western side of the Quad that would soon be filled with the modern administration building. Directly south of the Botany Greenhouses is what would later become the Science Quadrangle. At this point, that area was an amalgam of different buildings, most of which were strictly Spartan in their nature and execution. Moving west to Maryland and Drexel Avenues, most of this area would later be used for various additions to the University of Chicago Hospitals, including the Duchossois Center for Advanced Medicine at 58th and Maryland. Also conspicuous by their absence are the pre-fab housing units that the university would later build to house veterans and their families who entered under the GI Bill program. (Map Collection, The University of Chicago Library.)

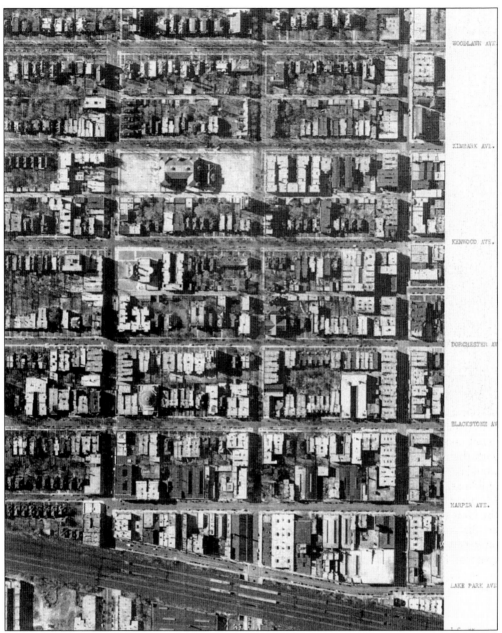

WOODLAWN AVE.

KIMBARK AVE.

KENWOOD AVE.

DORCHESTER AV

BLACKSTONE AV

HARPER AVE.

LAKE PARK AVE

Again from the same photo series, the northern edge of this aerial shot shows 55th Street approximately one decade before its imminent removal as part of the urban renewal project. At the bottom right-hand corner of the photo, the retail structures that backed up to the Illinois Central right of way are visible as well. Starting at 55th Street, these structures ran all the way to 47th Street and included the popular Morton's Restaurant and the Hyde Park Police Station. Also present are the older structures between Harper and Lake Park Avenues, which were also removed as part of the Hyde Park renewal project. The only structures allowed to remain in that tract were the Commonwealth Edison substation and the Ritz Car Garage at 55th and Lake Park, which challenged the blighted status of their building, and were allowed to stay provided they rehabbed their main façade. (Map Collection, The University of Chicago Library.)

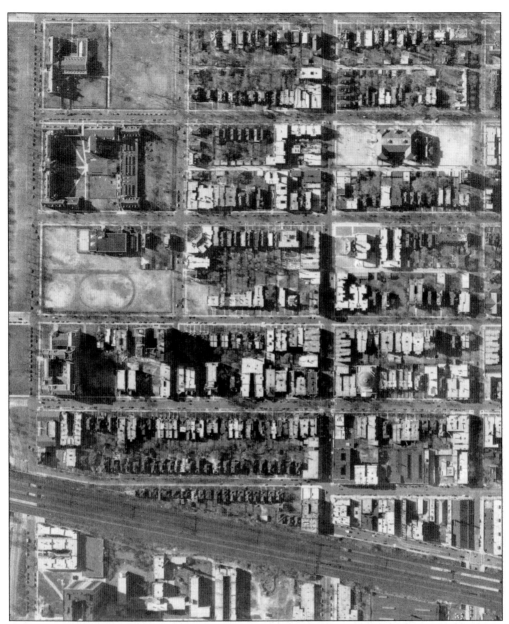

The last in a series of aerial maps, the top left-hand corner of the photograph shows Ida Noyes Hall, the women's recreational center at the university. North of the structure is Dudley Field, which would shortly be used to build pre-fab housing units, and later Woodward Court, a women's dormitory. The small homes directly west of the IC tracks between 57th and 59th Streets were part of a late-19th-century development called Rosalie Court. Begun in 1883, the street was originally a private one, but later opened shortly after annexation to the city in 1889, with the rest of Hyde Park. In the early 1920s, the university began to purchase homes on the block in an attempt to provide space for a new power plant. While the location would have been ideal due to the ease by which coal could be unloaded from the IC tracks (which were at grade level with the homes at this time), a coalition of local residents blocked their efforts to have the area rezoned, and the university subsequently built the plant across the Midway at 61st and Blackstone.

Woodworth's was a popular bookstore on the south side of 57th Street near Kimbark Avenue. Equally well known was the decaying tree trunk in front of the store on which locals and students alike would place want ads and other announcements. (Private Collection.)

Hyde Park had two Woolworth stores in close proximity to each other—one on 53rd Street (shown here) and another one in the Hyde Park Shopping Center on 55th Street. This branch lasted until 1995, and the other branch closed when Woolworth's filed for bankruptcy several years later. Today the 53rd Street location is a private gym.

Norman Maclean was one of the most beloved members of the English Department at the University of Chicago for over four decades. During his time at the university, he won the award for undergraduate teaching twice—once in 1940, and again in 1973. Seen here wearing one of his signature ties, Professor Maclean was also an accomplished writer, often drawing on his experiences as a young man growing up in Montana. His most famous short story, *A River Runs Through It*, was made into a well-received film shortly after his death. (Private Collection.)

Professor Fermi came to the university to work on the Manhattan Project and remained in the Department of Physics until his untimely passing in 1954. Professor Fermi had a special fondness for teaching, and his lectures are fondly remembered by those fortunate enough to sit in his classroom. (Private Collection.)

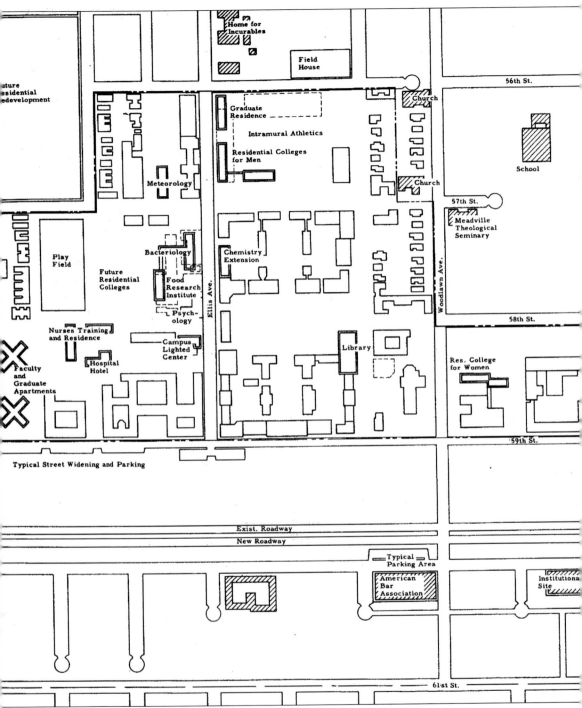

This is one of the suggested development plans contained within the report on community preservation prepared by the Metropolitan Housing and Planning Council. This particular section was produced by Professor Harvey Perloff and graduate students in the Program in Education and Research in Planning. The plan embodies much of the prevailing physical planning philosophy idiom in the early 1950s: there are "superblocks" and a profusion of

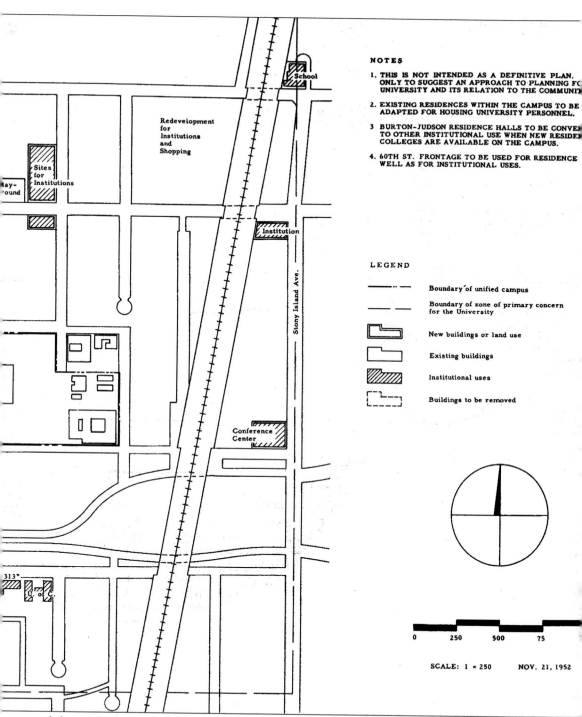

NOTES

1. THIS IS NOT INTENDED AS A DEFINITIVE PLAN.
ONLY TO SUGGEST AN APPROACH TO PLANNING FC
UNIVERSITY AND ITS RELATION TO THE COMMUNIT

2. EXISTING RESIDENCES WITHIN THE CAMPUS TO BE
ADAPTED FOR HOUSING UNIVERSITY PERSONNEL.

3 BURTON-JUDSON RESIDENCE HALLS TO BE CONVE
TO OTHER INSTITUTIONAL USE WHEN NEW RESIDE
COLLEGES ARE AVAILABLE ON THE CAMPUS.

4. 60TH ST. FRONTAGE TO BE USED FOR RESIDENCE
WELL AS FOR INSTITUTIONAL USES.

LEGEND

Boundary of unified campus

Boundary of zone of primary concern for the University

New buildings or land use

Existing buildings

Institutional uses

Buildings to be removed

0 250 500 75

SCALE: 1 = 250 NOV. 21, 1952

cul-de-sacs both in Hyde Park and the area between 60th and 61st Streets. What is most interesting is the large rectangle of land reserved for "Future Residential Development" at 56th and Cottage Grove. This area would become some of the most highly contested territory in the discussions about private redevelopment in southwest Hyde Park. (Metropolitan Planning Council.)

89

The director of the Orthogenic School for 25 years, Bruno Bettelheim was also a professor in the Department of Psychology. Professor Bettelheim was one of the most well-known figures in the treatment of behaviorally disordered children, penning dozens of books, including *Love is Not Enough* and *The Uses of Enchantment*. (Private Collection.)

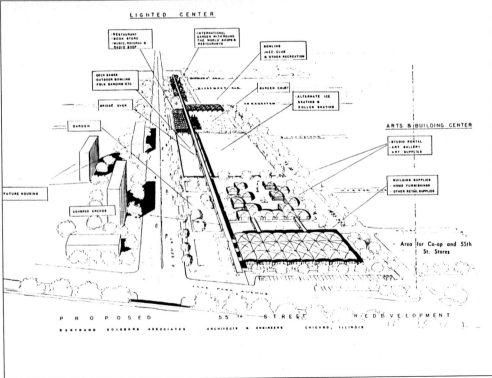

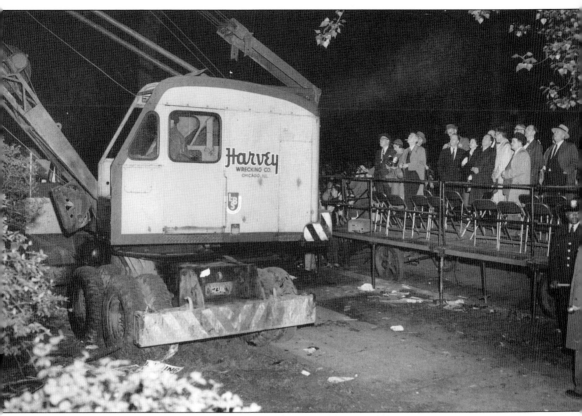

On May 10, 1955, the beginning of the Hyde Park Urban Renewal Project commenced with the demolition of an old frame house at 5456 South Blackstone. Dignitaries at the event included Mayor Daley, D.E. Mackelmann, the housing coordinator for the City of Chicago, and members of the Chicago Land Clearance Commission. The home was purchased by the Chicago Land Clearance Commission from Byron and Donna Sisler, who commented in a *Hyde Park Herald* editorial that they felt the price they received was "quite fair." While the tone at the ceremony was quite upbeat, certain community members took exception to the "carnival-like atmosphere of the proceedings." The Chicago Land Clearance Commission would continue their work around 55th and Lake Park that year and continue to move west on 55th Street. (Private Collection.)

(*opposite*) In 1955, Harvey Perloff, then a professor in the Program in Education and Research in Planning at the University of Chicago, presented his vision of how to redevelop 55th Street after the urban renewal project was completed. Working with architect Bertrand Goldberg, Perloff articulated a vision of an elongated rectangular development stretching west down 55th Street, which would include a restaurant, a bookstore, an "international garden," bowling, a jazz club, a multipurpose skating rink, and an arts and building center. As Professor Perloff articulated in this study (which also appeared in the *Hyde Park Herald* in August of 1955), "The main principle proposed is that a 'core' shopping center be developed, not by imitating suburban development which starts with raw land, but by making adjustments to the existing built up situation." The response in the community to the Perloff proposal was overwhelmingly positive, with numerous letters of support and interest appearing in the *Herald* for weeks afterwards. The plan never came to fruition, the Program in Education and Research in Planning was soon discontinued, and Professor Perloff moved on to become dean of the Architecture and Planning School at UCLA. (*Hyde Park Herald*, Bruce Sagan, and Miriam Perloff.)

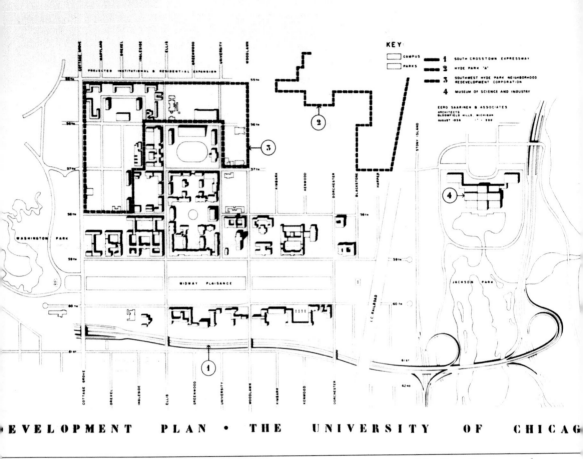

The preliminary 1955 University of Chicago master plan was prepared by Eero Saarinen, who was also responsible for the masterful execution of the Law School quadrangle, which rose several years later on the Midway in the block next to Burton-Judson Courts. In this plan, 59th and 60th Streets are imagined as cul-de-sacs, preventing traffic from flowing into Stony Island Avenue. This was to take place in conjunction with the creation of an expressway that would travel down 61st Street from the lakefront and connect with the newly emerging expressway running southwards from the western edge of the Loop. While the description of this new expressway was illustrated in public meeting as a "way to effectively reunite the south campus to the area north of the Midway," a description offered by a top administrator at a meeting of the board of trustees offers another potential explanation, "The area south of 61st Street has gone beyond any possible hope of rehabilitation, and we should seek other options." The university already held much of the property between 60th and 61st Streets, and if such a plan was adopted, the city and other public agencies would have to purchase the remaining properties through eminent domain. (Department of Special Collections, The University of Chicago Library.)

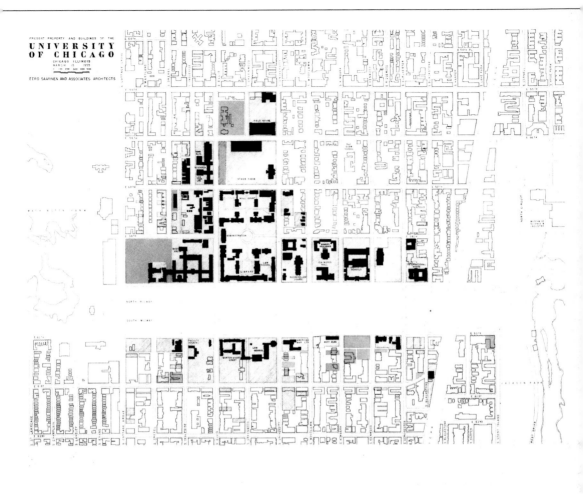

In this alternative master plan prepared in 1955 for the university, the Law School Quadrangle is present south of the Midway next to Burton-Judson, along with the American Bar Association building. Priorities for the university included the construction of new dormitories for the planned expansion of the college, the creation of a new applied research park (which did not come to fruition), and the control of the area immediately to the north and west of the main campus area. While the area contained some blighted structures, the university expressed grave concerns that the rest of the area would soon deteriorate to the point of resembling the rather bleak area that was undergoing redevelopment near the Illinois Central tracks at 55th Street as part of the Hyde Park "A" renewal project area. (Private Collection.)

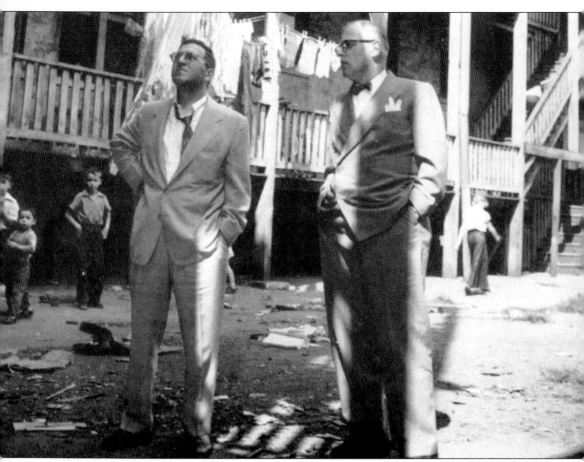

Jack Meltzer, the head of the University of Chicago Planning Unit, and Julian Levi, the head of the South East Chicago Commission, inspect a tenement building in Hyde Park in 1958. Before coming to the university, Mr. Meltzer had served as planning supervisor at Michael Reese Hospital, where he had helped direct part of the redevelopment area immediately surrounding the hospital. Julian Levi, brother of the dean of the Law School, Edward Levi, was the longtime director of the South East Chicago Commission, which was charged with the monumental task of documenting building code violations in the area. Levi was also extremely aggressive in the prosecution of landlords who illegally converted old homes and apartment buildings in Hyde Park and Kenwood. While there were many who did not care for Mr. Levi's particular *modus operandi*, he was quite effective at what he set out to do, even if at times he seemed to care little for people's opinions or their protestations. (Private Collection.)

Three

WHEN HYDE PARK
HAS BEEN 'DONE OVER'
THE HUMAN SIDE
OF BOTH PUBLIC AND PRIVATE URBAN RENEWAL

As the process of urban renewal continued throughout the middle and late 1950s, many individuals in Hyde Park—including quite a few small businessmen—were surprised by the number of buildings that were being demolished along 55th Street. Some businessmen from 55th and Lake Park Avenues who moved west to avoid urban renewal soon found themselves once again being displaced by a Community Conservation Board that seemed "quite zealous" to rid the area of even the most remotely questionable building. While some residential units in the urban renewal area were being reconverted and rehabbed, there were little or no funds available for commercial rehabilitation. While there were certain merchants who lobbied for a new retail space at the northeast corner of 53rd and Woodlawn Avenues, many small businessmen had to move elsewhere as a result. Later studies by Professor Brian Berry of the University of Chicago revealed that many businessmen felt the demolition program was overzealous and that little or no assistance was offered to them during the process.

Perhaps the most controversial aspect of urban renewal in Hyde Park was the private redevelopment program proposed by the South West Hyde Park Redevelopment Corporation. Under the Neighborhood Conservation Act of 1953, three individuals could form a redevelopment corporation with the intent to stop the spread of blight throughout a community. The corporation was formed by several officers of the university, including Chancellor Lawrence Kimpton and Julian Levi. While the officers lived within the proposed redevelopment area, they lived a substantial distance from where any proposed demolition or construction was to take place. St. Clair Drake, a resident of southwest Hyde Park and a noted sociologist at Roosevelt University, took exception to the designation of his community as "blighted," and began his own study into the report on the area. Upon closer examination, St. Clair Drake's group discovered that one house that had been declared "dilapidated" on South Maryland Avenue was merely missing one front porch board. Bringing this information to the Community Conservation Board, Professor Phillip Hauser of the Sociology Department at the University of Chicago testified on behalf of the redevelopment corporation, stating that "once the process of exploitive land use has started, experience indicates that it cannot be stopped." While the Community Conservation Board later approved the plan by a vote of two to one, Professor Drake filed an appeal to the Supreme Court of Illinois that was dismissed due to a procedural error. The University and the Redevelopment Corporation began demolition of the structures between Cottage Grove and Ellis Avenue from 55th to 56th Streets in early 1958, only saving four buildings which were to be used for graduate student housing. A reporter from the *Hyde Park Herald* went through the area before the demolitions began to record some of the local sentiments regarding the renewal program in their area. One woman had this to say: "These educated people pat us on the back with one hand and take the bread out of our mouth with the other. They think we're blind . . . They know we won't be here when Hyde Park has been 'done over.'"

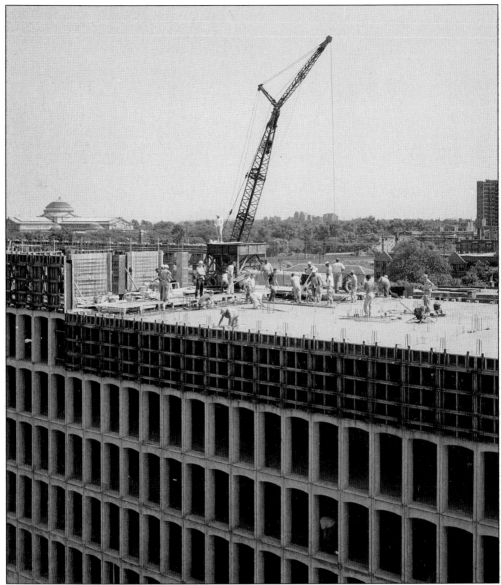

After the demolition of the buildings involved in the Hyde Park "A" and "B" Urban Renewal areas, the Land Clearance Commission opened competitive bidding on the property. Competitors included several nationally known developers, including Webb & Knapp, and several local investors. On April 3, 1957, the Chicago City Council approved the plan of the New York firm of Webb & Knapp. Their plan provided for the construction of 267 row houses and 528 apartment units on both sides of 55th Street west of Harper Avenue. The plan also included a provision for a 9-acre shopping center at the northwest corner of 55th and Lake Park. While many in the Hyde Park community expressed excitement over the new developments, which included the construction of two large apartment towers in the middle of 55th Street, others called the project "a monstrosity" and criticized the "arbitrary segregation by income" that seemed to be one of the guiding principles behind this redevelopment plan. Shown here is a photograph of the construction of the two apartment buildings in 1960. (University of Chicago News Office.)

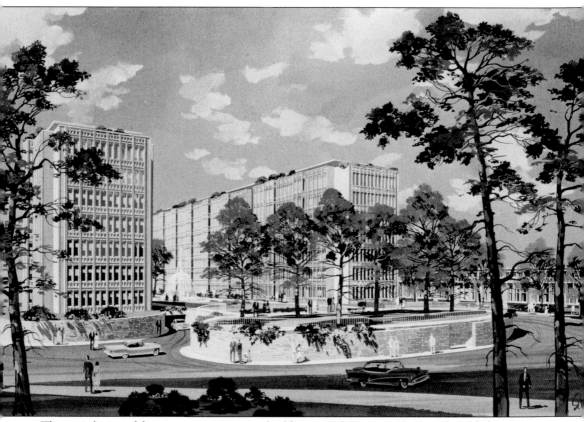

The completion of the university apartment building at 55th Street in 1961 was heralded as a new era in apartment living in Hyde Park. The buildings were executed by the modern architect I.M. Pei, and it was hoped that by placing the apartments in the middle of the newly reconstructed 55th Street that vehicles would slow down as they drove around the structures. In practice this did not happen, and the buildings soon acquired the unflattering nickname, "Monoxide Towers." This rendering shows the space between the buildings as a pedestrian thruway; in the final plan, this space was closed off, and a large iron fence was placed around the two buildings. Over time, the apartments have continued to be quite popular despite earlier questions about their size and placement in the urban grid. (University of Chicago News Office.)

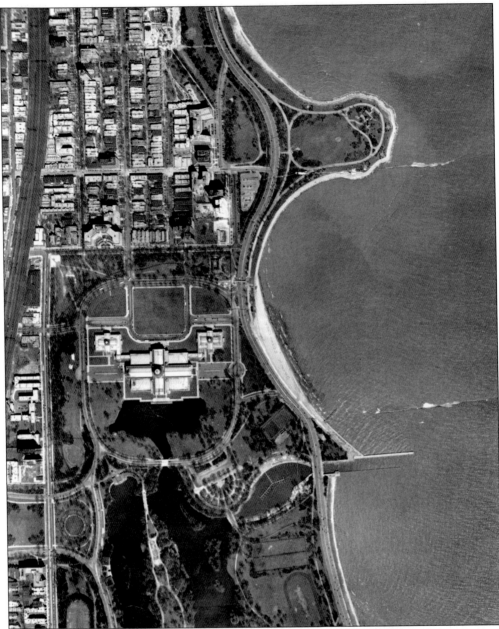

This aerial photo taken in 1949 shows the demand for land in East Hyde Park. While most of the property had been developed by the early 1930s, several sites remained vacant until the early 1950s. The future Sinai Temple can been seen under construction in the top middle section of the photograph. Other notable buildings include the massive Plaisance Hotel east of the Illinois Central tracks on 60th Street near Stony Island Avenue. The only undeveloped property on the lakefront was the corner lot at 56th and the lakefront. This property would soon see the arrival of the Shore Motel and later Morton's Restaurant, which was displaced due to the initial stages of urban renewal along Lake Park Avenue. In 1991, the site was redeveloped for Montgomery Place, a luxury high-rise building for the elderly. (Map Collection, The University of Chicago Library.)

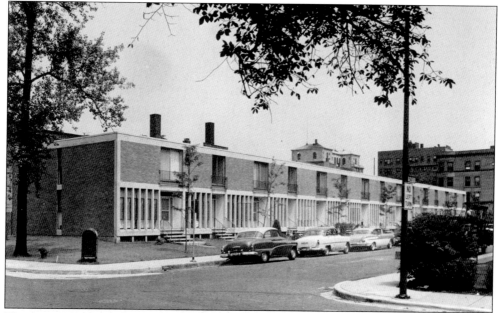

These attractive townhomes at 54th Place and Dorchester were part of the same Webb & Knapp redevelopment of this part of Hyde Park. The residences themselves were modeled after 18th-century English townhomes, with a sympathetic nod to the remaining late 19th-century structures by their use of brick as a building material. (University of Chicago News Office.)

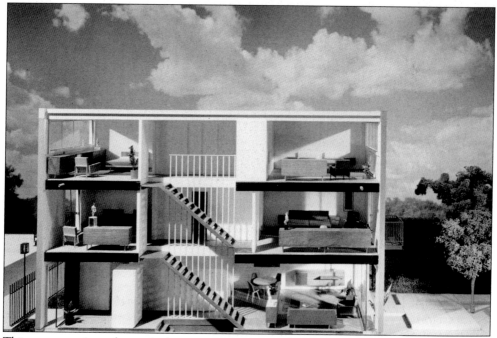

This cross section of a typical new townhome in the Hyde Park redevelopment project emphasizes the flexibility of the different spaces in each unit. While certain members of the community predictably expressed their reservations about the aesthetic merits of the structures, they remain popular residences in the community. (University of Chicago News Office.)

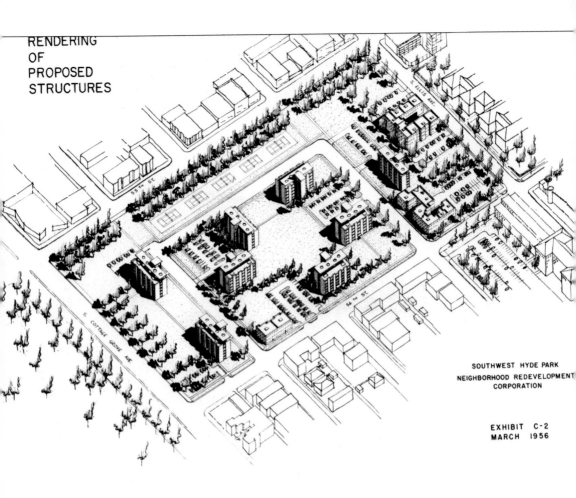

RENDERING
OF
PROPOSED
STRUCTURES

SOUTHWEST HYDE PARK
NEIGHBORHOOD REDEVELOPMENT
CORPORATION

EXHIBIT C-2
MARCH 1956

The Southwest Hyde Park Redevelopment Corporation is perhaps the most contested aspect of urban renewal and private redevelopment efforts in Hyde Park. Implementing a law that was modified in the early 1950s, members of the university community (including President Lawrence Kimpton and Julian Levi, head of the SECC) formed a redevelopment corporation that was set on purchasing the land between 55th and 56th Streets and Cottage Grove and Ellis Avenues in order to build married student housing. While this maneuver was completely legal, residents of Southwest Hyde Park complained that their neighborhood was in fact not blighted, and even scrutinized a plan prepared by the members of the Southwest Hyde Park Redevelopment Corporation that stated the entire section was in fact "beyond rehabilitation." The resident opposition was led by sociologist St. Clair Drake (who in fact was an alumnus of the university), who fought the university's claims that the community was in fact on a downward spiral towards complete deterioration. Although the Supreme Court refused to hear an appeal by St. Clair Drake and his associates, the university reneged on this ambitious building plan and embarked on a vigorous program of purchasing apartment housing in other parts of the community (a move that seemed more sensible to certain university administrators). No housing was ever developed on the site, and the cleared area is now the modern-day Stagg Field. (University of Chicago News Office.)

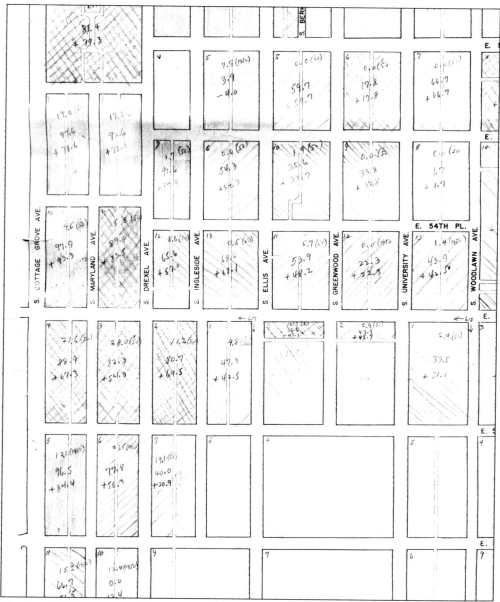

The late Sol Tax was one of the most well respected members of the Anthropology Department at the university, and a proponent of what he called "action anthropology." The aims of "action anthropology" were twofold: first, the anthropologist would attempt to become a part of the community he or she was studying; and secondly, they would also try to use their knowledge and expertise to effect some type of positive change or to serve as an advocate for the community in question. Professor Sol Tax took exception to the university's attempt to appropriate all of Southwest Hyde Park for its own, and spoke on the subject in an address to community leaders and in a long piece in the *Hyde Park Herald*. For this work, he created a map that showed the racial transition throughout Hyde Park from the period of 1950 to 1957. The top number indicates the percentage of African-American residents in the block in 1950, the middle number was the percentage in 1957, and the bottom number was the percentage increase from 1950 to 1957. (Map Collection, The University of Chicago Library.)

CHANDRASEKHAR

U
R
E
Y

F
E
R
M
I

Ten years after the historic first chain reaction was set off underneath the Stagg Field stands, the Physical Sciences Division of the University continued its pioneering in imporant research. World-famous in its reputation the division also conducts its research and teaching throughout the world.

The Astronomy Department operates at two observatories, Yerkes in Wisconsin and Mac-Donald in Texas. Cosmic ray observation at high altitudes is being conducted under the aegis of the University in the mountains of Bolivia, and by jet planes making regular flights between Alaska and New Orleans.

In order to make possible the study of radio-active decay of ancient materials, being carried on by the Chemistry Department, anthropological artifacts are being imported from the Near East.

The Physics Department is cooperating with the Brazilians in building a cyclotron in Brazil. Much closer to home, but off campus, the Argonne Laboratory continues the atomic research which the chain reaction ten years ago inaugurated.

B
Y
E
R
S

M
A
C
L
A
N
E

NEWHOUSE

This photograph of some of the members of the Physical Science Division faculty at the university features three Nobel Prize winners: Enrico Fermi, who received his Nobel in 1938; Subrahmanyan Chandrasekhar, who received his Nobel in 1983; and Harold Urey, who received the Nobel Prize in 1934. By the early 1950s, the university had several modern physics labs at its disposal, including the Argonne Laboratory. In addition, the Astronomy Department of the university operated two observatories, one in Wisconsin, and the other in Texas. The modern Research Institute Buildings on Ellis Avenue were completed in the early 1950s. The existing homes on the site were not demolished, but rather moved to the 5500 block of Ellis Avenue on large rollers, where they remained for the rest of the decade. (Private Collection.)

Proving that trends in musical tastes do sometimes come full circle, these young men are enjoying a folk music jam session. Using instruments that had not been in vogue since the early 1900s, the folk music phenomenon of the 1960s did not pass over the University of Chicago campus unnoticed. Around the same time, the popular University of Chicago Folk Festival began as an annual event on campus. (Private Collection.)

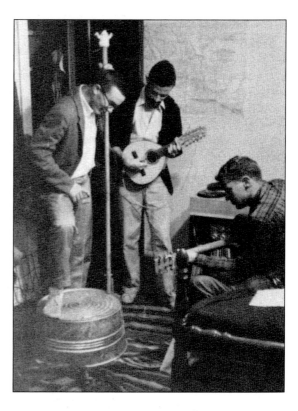

UNUSUAL FOOD

DELIGHTFUL

ATMOSPHERE

POPULAR

PRICES

TROPICAL HUT

Fifty-Seventh at Kenwood

The Tropical Hut on 57th and Kenwood was a local favorite for students for several decades before it was torn down by the Chicago Land Clearance Commission in the early 1960s. In the same mold as the House of Tiki on 53rd Street, the Tropical Hut featured a variety of exotic drinks and not-as-exotic foods. Shortly after the building was demolished, the Department of Urban Renewal closed Kenwood, created a cul-de-sac, and reversed the direction of the street. (Private Collection.)

MR. ESCOT: The use of vinous spirit has a tremendous influence in the deterioration of the human race.

MR. FOSTER: I fear, indeed, it operates as a considerable check to the progress of the species towards moral and intellectual perfection. Yet many great men have been of opinion that it exalts the imagination, fires the genius, accelerates the flow of ideas, and imparts to dispositions naturally cold and deliberative that enthusiastic sublimation which is the source of greatness and energy.

MR. NIGHTSHADE: Laudibus arguitur vini vinosus Homerus.

MR. JENKINSON: I conceive the use of wine to be always pernicious in excess, but often useful in moderation: it certainly kills some, but it saves the lives of others: I find that an occasional glass, taken with judgment and caution, has a very salutary effect in maintaining that equilibrium of the system, which it is always my aim to preserve; and this calm and temperate use of wind was, no doubt, what Homer meant to inculcate, when he said:

Πὰρ δὲ δέπας οἴνοιο πιεῖν ὅτε θυμὸς ἀνώγοι.

SQUIRE HEADLONG: Good. Pass the bottle.

—THOMAS LOVE PEACOCK

COMPASS TAVERN
1150 EAST 55TH STREET

In 1955, a group of men and women from the university community began to perform at the Compass Tavern in a makeshift performance space. Their number included David Shepherd, Elaine May, Paul Sills, Mike Nichols, and Severn Darden. From this group, a new and innovative style of improvisational theater was born out of the intellectual ferment of the area. After a time, the group moved to other locations in Hyde Park along Lake Park Avenue, and then eventually to the Old Town area around Wells Street. The Compass Tavern is now the site of a Chicago Fire Department facility. When asked why some effort hadn't been made to accommodate this group in the plans for urban renewal, Julian Levi replied that it wasn't something that had been brought to his attention. The group flourished and later developed into the organization that is known today as the Second City. (Private Collection.)

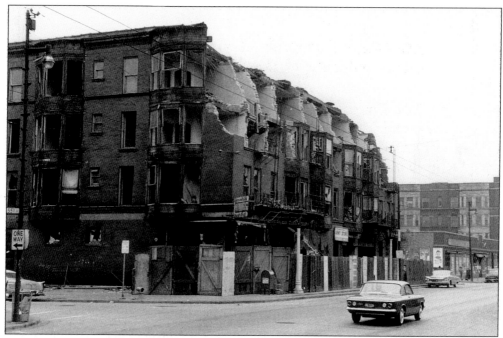

Looking northeast at the corner of 55th and University, demolition of the building that housed the Compass Tavern begins in 1960. On the right side of the photograph, the Woodlawn Tap is visible along with the soon to be condemned building at 55th and Woodlawn. The site of the Compass Tavern is now a fire station. (Private Collection.)

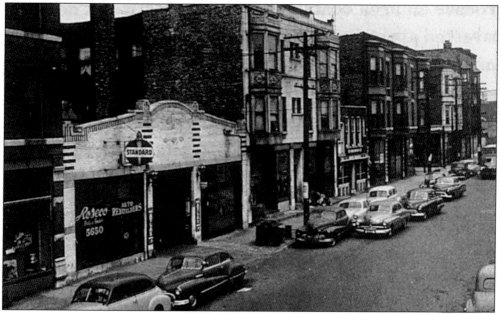

This shot, taken from one of the South East Chicago Commission's reports on Urban Renewal, shows the traffic congestion problems along Lake Park Avenue near 56th Street that had been of great concern to local residents. On-street parking was allowed on both sides of the street, and the street remained bi-directional until it was redeveloped. (South East Chicago Commission.)

The Hyde Park Shopping Center was again a touchstone for both criticism and praise within the Hyde Park community. While many enjoyed the ease by which the center could be accessed by automobiles, many local merchants displaced by the continuing process of urban renewal in the immediate area were furious when they found out that few local merchants would be able to secure space in the new structure. Despite the efforts of Fifth Ward Alderman Leon Despres to secure adequate assurances that local merchants would receive first preference in the new center, Webb & Knapp remained somewhat oblivious to the needs of small businesses. Two community institutions, however, did receive space in the new development—Cohn and Stern, the men's clothier, and the Hyde Park Cooperative Market, which moved there from 56th Street. At the time of its arrival into the shopping center, the Hyde Park Co-Op was the largest grocery store in the city of Chicago. (University of Chicago News Office.)

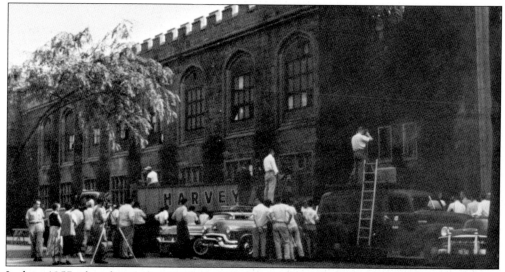

In late 1957, the plaque that marked the site of the first self-sustained chain reaction was removed from the West Stands in preparation for their imminent demolition. There was some discussion among the board of trustees regarding the potential preservation of the site, but ultimately the stands were demolished. (Private Collection.)

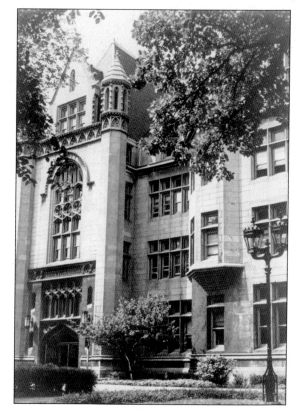

Another example of overcrowding was the state of affairs in Cobb Hall by the early 1960s. Numerous offices, including the School of Social Service Administration, had been squeezed into the building in order to accommodate a variety of uses. The conversion of nearby Gates and Blake Halls freed up some room in the building, and SSA shortly left for its own building across the Midway in 1965.

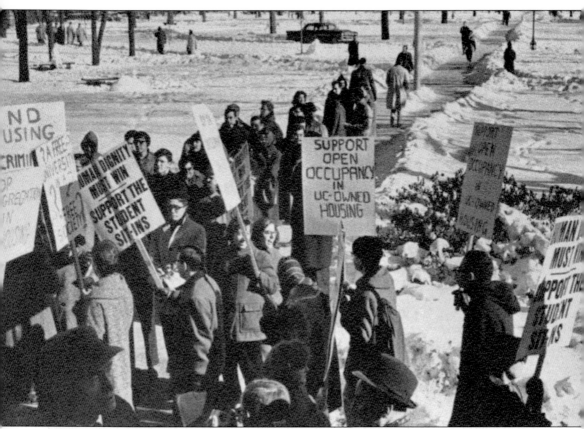

In January of 1962, the campus chapter of the Congress on Racial Equality and sympathetic students protested the segregation of the university's off-campus rental properties. CORE sponsored several test cases where black and white students were sent to apply for the same off-campus apartments held by the university's realty company; in each case, black students were not offered housing contracts, while every white student received an offer of housing. President George Beadle issued a statement that said the purpose of the university is to attain, "stable integration in all phases of community life." He then went on to add that, ". . . we must achieve this at a rate that is tolerable as far as all the people are concerned." At the end of the month, a group of students staged a sit-in in front of President Beadle's office in the administration building, even after he left for a trip to California. Letters to the *Hyde Park Herald* seem to support the position of the protesters, including one observer who rather bluntly queried, "How can other real estate companies practice integration in Hyde Park when University Realty, the big landlord of the community, won't take the lead?" President Beadle agreed to appear at a public meeting in the theater of Ida Noyes Hall, where there was more than a small amount of conflict and shouts from the assembly. A faculty committee composed of Allison Dunham, Phil Hauser, and George Schultz (later to become a member of President Reagan's cabinet) was established to examine the issue and adopt a few preliminary recommendations. While their report was critical of certain policies within the university's off-campus rental properties, they noted that, "on the other hand, managed integration in a predominantly Negro sector may sometimes best be served by maintaining an all-white building." (Private Collection.)

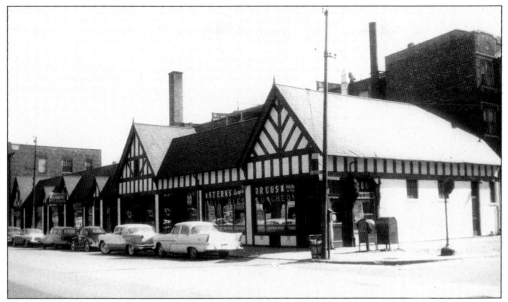

The Reader's Drugstore was one of the longtime tenants of this rather unusual pseudo-Tudor building at the southeast corner of 61st and Ellis. Long a favorite haunt of university students and residents of Burton-Judson Courts, the building experienced a high rate of vacancies in the late 1950s, and was eventually shuttered. The building was later replaced by a rather bland set of townhomes that required a great deal of curb cuts to accommodate their parking garages. (Private Collection.)

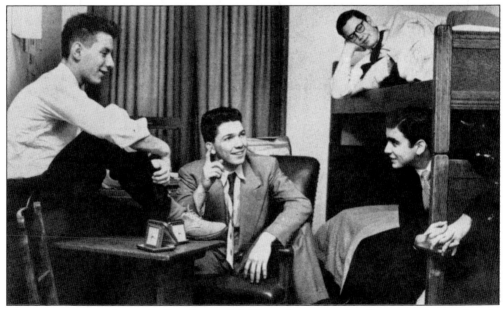

These young men are enjoying the social life and opportunity for group interaction in Burton-Judson Courts, one of the University of Chicago dormitories, located at 60th and Ellis. While there are few retail shopping opportunities on this side of Midway, these students were fortunate to have the commercial buildings at 61st and Ellis to patronize, including the popular Reader's Drugstore. (Private Collection.)

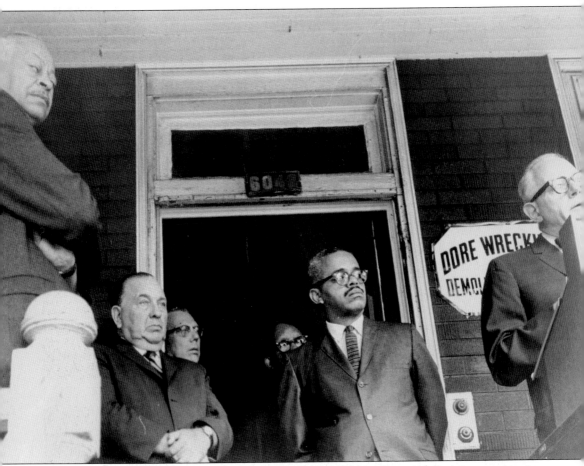

Twelve years after the inauguration of the Hyde Park Urban Renewal Project, community leaders, elected public officials from the city, and Julian Levi came to initiate the urban renewal efforts in Woodlawn. The building being demolished on that date was again symptomatic of Woodlawn's problems: a two-story home had been converted to five dwelling units, including a basement apartment. The program was originally slated to focus solely on the area between 60th and 61st Streets, which consisted of properties owned by the university. Due to the protestations of various community leaders, including Arthur Brazier, head of the Woodlawn Organization, the activist Saul Alinsky, and the independent Alderman Leon Despres, the university had to adjust their plans accordingly. The newly approved plan included provisions for low and middle-income housing to be built along Cottage Grove Avenue and made a certain amount of federal money available to achieve this project. From left to right are: Claude Holman, Fourth Ward Alderman; Mayor Richard J. Daley; and at the rostrum, Julian Levi, director of the South East Chicago Commission. (University of Chicago News Office.)

The Hyde Park Arms is one of the few remaining transient hotels in the area. While the building was listed on an internal University of Chicago real estate document as a "threat property" in the late 1950s, the building was never purchased by the university and remains an affordable alternative place of residence for single men. (Max Grinnell.)

The Harper Crest at 54th and Harper Avenues was a popular hotel with a small café until the early 1950s. When this building did make the same "threat property" list due to its lack of tenant selection and the dubious activities of the residents, the university did buy the property and converted it into much needed graduate student housing, which remains the current status of the building. (Max Grinnell.)

The Dorchester Apartments, also known as the Stein Building, were built in 1968 in an effort to provide luxury residences for faculty at the university. It is said that the structure contains more Nobel Prize winners than any other building in the world. (Max Grinnell.)

The construction of these townhomes at 56th and Harper was begun in 1959, after the removal of the older structures on the block. Many of the townhomes in this block were organized around an oval-shaped green area that served as a play area for the young children who lived nearby. (University of Chicago News Office.)

After the demolition of the Artist's Colony at 57th and Stony Island, a number of Hyde Park residents were fearful that urban renewal would effectively eliminate any affordable rental space for the eclectic mix of eccentric artists and other characters in the area. Muriel Beadle, wife of University of Chicago President George Beadle, spearheaded the effort to build Harper Court, which would serve as a replacement facility for artisans and other specialty stores. By the time the building was open in 1965, many of the artists had moved on to Old Town, only to be displaced by the heavy-handed urban renewal efforts of Arthur Rubloff. Harper Court remains one of the most well-designed and attractive public spaces in Hyde Park today. (Max Grinnell.)

When the sculptor Lorado Taft died, he left his home and studio at 60th and Ingleside to the university. Today the buildings are both National Historic and City of Chicago landmarks. Currently they house the university's Art Department. (Max Grinnell.)

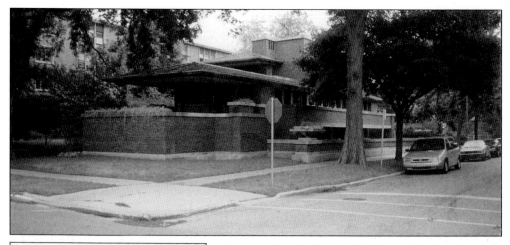

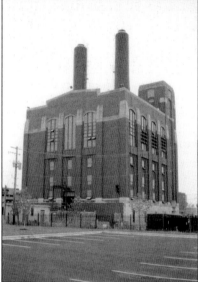

One of the most famous homes in the world, the Robie House by Frank Lloyd Wright, has stood on the corner of 58th and Woodlawn for over 90 years. While the building is now under the stewardship of the Frank Lloyd Wright Home and Studio Foundation, the building was once under threat of demolition in 1957, when the Chicago Theological Seminary announced that they wanted to build dormitories on the site. A compromise was eventually reached, and the seminary built their dorms immediately north of the Robie House. (Max Grinnell.)

After unsuccessfully attempting to locate the Steam Plant near Harper Avenue north of the Midway, the university selected a site at 61st and Blackstone. Immediately across the IC tracks at 6052 South Harper Avenue, Hugh Hefner laid out the plans for the first issue of *Playboy* in 1953, at his walkup apartment building.

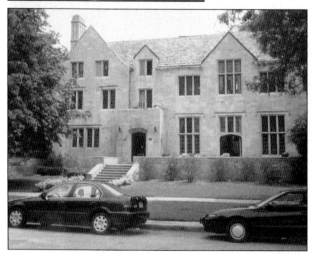

While interest in Greek organizations would wane beginning in the early 1960s, the Alpha Delta fraternity building was constructed in 1929, and is the newest fraternity building on campus. Probably the most well known Alpha Delta Phi in the university community at the time was the newly arrived President Robert Maynard Hutchins, who made several stops at the house to assure the young men that he felt that fraternities were a necessary adjunct to the college experience. (Max Grinnell.)

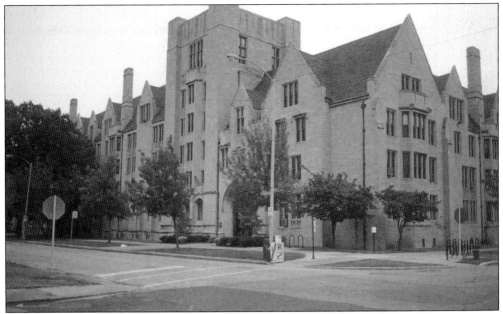

Completed in 1931, Burton-Judson Courts were originally built as a men's dormitory that would be the first step in moving the College of the University over to the south side of the Midway and into its own self-contained quadrangle. The Depression and the availability of funds intervened, and it remained the only dormitory on the south side of the Midway until the New Graduate Residence Hall was built in the 1960s. (Max Grinnell.)

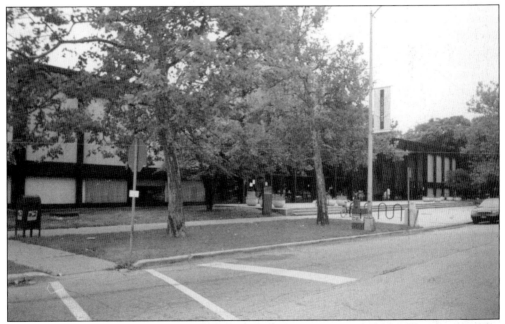

The School of Social Service Administration moved from its cramped Cobb Hall location into this Mies van der Rohe building in 1965. Some users of the building complained about the basement offices, which lacked windows and seemed a bit stifling, but most observers find much to admire about yet another one of the master architect's exercises in glass and steel. (Max Grinnell.)

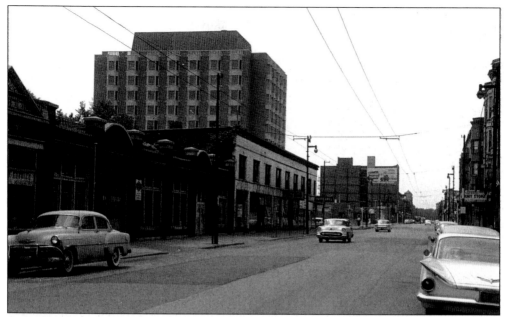

Demolition continued in earnest throughout 1960 along the southern side of 55th Street. The university had cleared the land on the south side of the street between Greenwood and University Avenues for construction of the new men's dormitory, Pierce Tower. Beyond the Harry Weese designed dormitory is the Peterson Warehouse building. In the left foreground are several automobile garages, which specialized in foreign car repair. (Private Collection.)

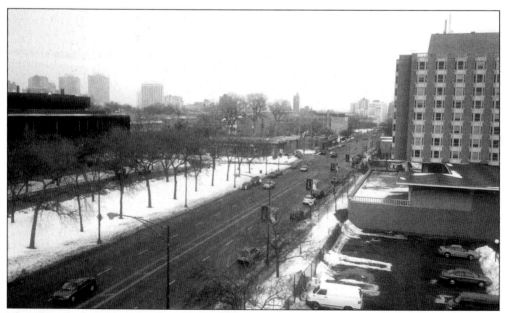

This shot, looking east from 55th and Ellis, shows the area surrounding 55th Street today. A planned matching tower to complement Pierce was never constructed, but the Lutheran Theological Seminary constructed their own quadrangle on the north side of 55th Street in 1966. The only building in this photograph that remains from before urban renewal is the one-story brick structure beyond the fire station at 55th and Woodlawn. (Jay Shuffield.)

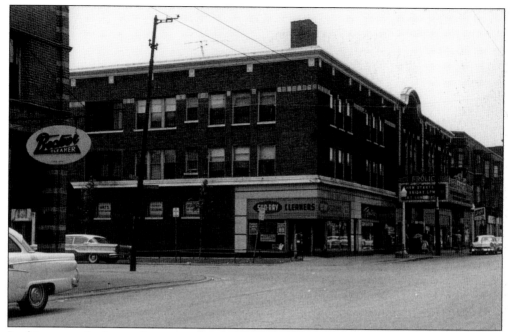

Looking towards the southwest corner of 55th and Ellis, the popular Frolic Theater is visible. These properties were later acquired by the South West Hyde Park Redevelopment Corporation on behalf of the university, and were demolished for the construction of married student housing. Today the area is a parking lot and the modern Stagg Field. (Private Collection.)

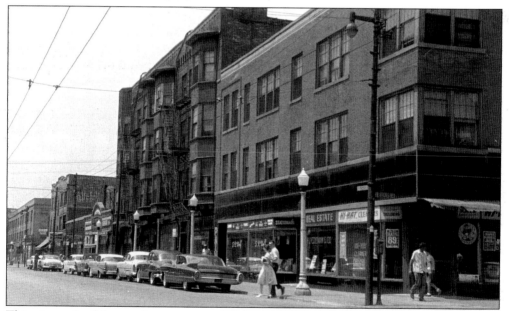

This picture is of the northwest corner of 55th and Ellis, another building that was eventually demolished in late 1961. Many of these buildings along 55th Street contained a fair contingent of newly arrived white families from Appalachia, along with African Americans who were moving out of the older and crowded Black Belt and who had been displaced by other urban renewal efforts such as the Lake Meadows projects. (Private Collection.)

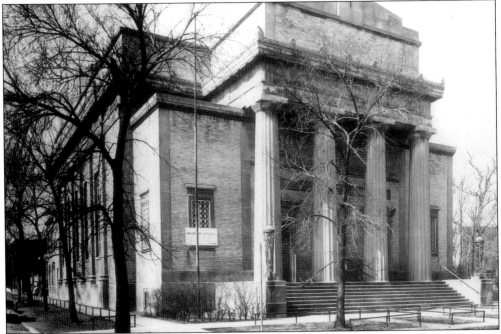

The Jewish congregation at Rodfei Zedek had just finished their new temple at 52nd and Hyde Park Boulevard when the university brought their previous home at 54th Place and Greenwood in the early 1950s. The university tried to rent the property to other interested parties but with little success, and the property was later razed. (Private Collection.)

Faculty at the university had favored the 5200 and 5300 blocks of University and Greenwood Avenues for many years by the time of this photo in the late 1950s. Professors who lived in this block included Maynard Krueger, the economist and one-time Socialist candidate for vice president, physicist Enrico Fermi, and historian William McNeill. (Private Collection.)

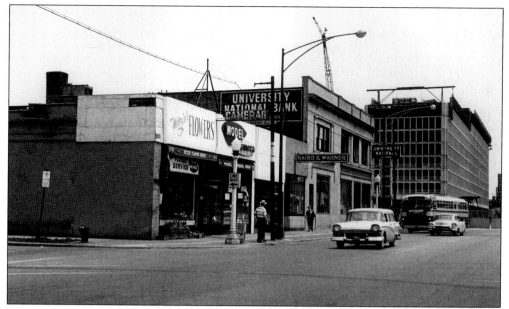

Besides the building at 55th and Woodlawn, the only other buildings that were retained along 55th Street during urban renewal were the structures at the northeast corner of 55th and Kenwood. The University National Bank underwent a substantial rehabilitation, as did the two adjoining storefronts. (Private Collection.)

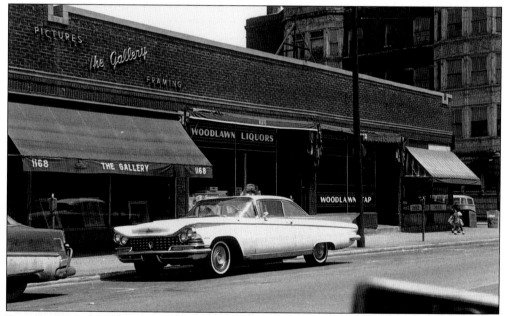

Due to overwhelming support for the Woodlawn Tap (also known as Jimmy's), the building was retained and renovated during the late 1950s. Several students who lived nearby wrote pleading letters to the *Hyde Park Herald* to act as an advocate for those who wanted to have "just one place to get a beer." While 55th Street did certainly have its share of bars (approximately 20 alone west of Woodlawn Avenue), others felt that the bars were only for "the basest elements of our community." (Private Collection.)

This large commercial building in the 1100 block of 55th Street was like many others in the area slated for demolition by the Chicago Land Clearance Commission. The building contained several small stores that catered to local residents and students alike. Somewhat prophetically, the building also contained a moving service that helped residents relocate after the structure was condemned. (Private Collection.)

While the retail businesses in the first floor of this building at the northeast corner of 55th and Woodlawn were quite solvent, the apartment units were in complete disarray, with many units lacking basic plumbing facilities or heating devices. The Clark and Clark bookseller at 1204 East 55th Street was a longtime tenant that was forced to move nine times as a result of urban renewal before finally going out of business in the late 1960s. (Private Collection.)

The Biltmore Apartments on the northeast corner of 53rd and Harper had seen better days by the late 1950s, and the Chicago Conservation Board condemned the building in 1962. The space remained a parking lot until a one-story building was built to house a coffee shop and a record store in the early 1990s. (Private Collection.)

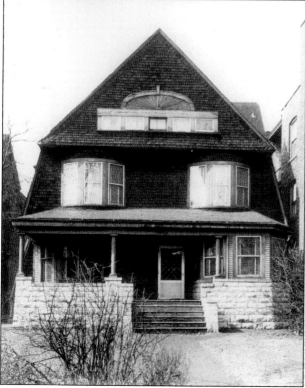

During the debate over where to place the few units of public housing that eventually were included in the Hyde Park Urban Renewal Plan, numerous block clubs came out against placing any scattered site CHA housing in their block (including several block clubs in the mostly African-American area of northwest Hyde Park). The 5600 block of Dorchester was one such exception, and eventually this home at 5610 South Dorchester was demolished for several units of public housing. (Private Collection.)

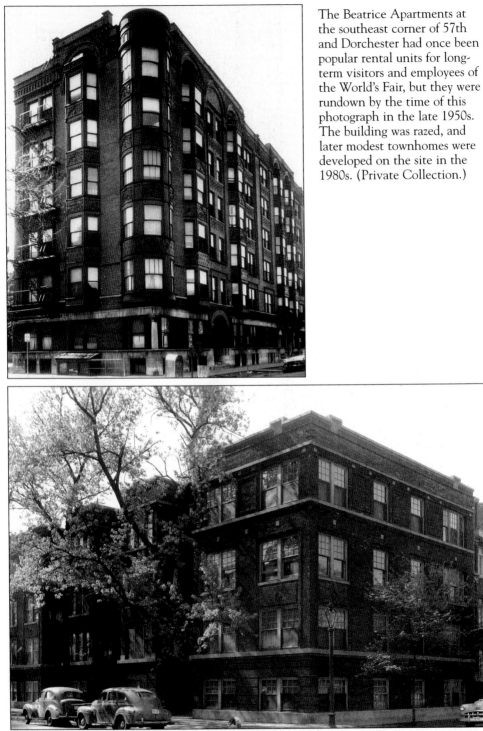

The Beatrice Apartments at the southeast corner of 57th and Dorchester had once been popular rental units for long-term visitors and employees of the World's Fair, but they were rundown by the time of this photograph in the late 1950s. The building was razed, and later modest townhomes were developed on the site in the 1980s. (Private Collection.)

This building at 58th and Maryland was purchased in the 1950s for use as a nurse's residence. The building was also used as office space for the university until it was demolished for a new hospital building that went up in 1996. (Private Collection.)

This residence at 5755 South Dorchester was largely occupied by students and members of the university community when it was purchased and demolished to make room for a parking lot, which would serve the Cloisters apartment building across the street. (Private Collection.)

This structure at 5815 South Dorchester and the two surrounding buildings were purchased by the university and demolished in anticipation of new construction to accommodate faculty members. The Cloisters building is visible on the left-hand side of the photograph. (Private Collection.)

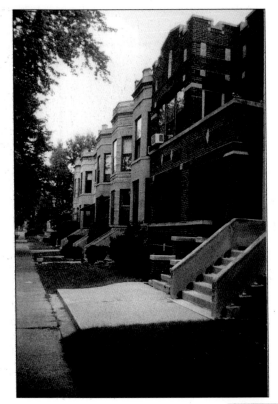

While the 5600 block of South Drexel is quiet today, it was once the site of much consternation and debate regarding the proposed redevelopment of southwest Hyde Park in the 1950s. The block was well organized during the 1950s, and they sponsored several fund-raisers for the Southwest Hyde Park Club. (Max Grinnell.)

This stately building at 5614–16 South Drexel was an equal mix of black and white residents by the early 1950s. Along with a dozen or so apartments, the building also housed a grocery store and a doctor's office. While the building provided a convenient place for shopping for nearby elderly residents, the proposal to include some small shopping areas for southwest Hyde Park never materialized. (Private Collection.)

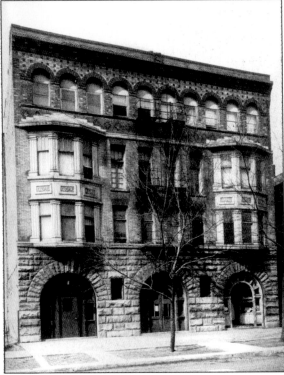

This brick building at 5558 South Ellis was home to the Southwest Hyde Park Neighborhood Club and the Hyde Park Youth Project until it was demolished for the Southwest Hyde Park Redevelopment Plan. (Private Collection.)

This apartment building stood at 5608–10 South Ingleside across from the Botany Greenhouses on the other side of the street. While the building was of sound condition, it was demolished to make way for campus expansion in the middle of the 1950s. (Private Collection.)

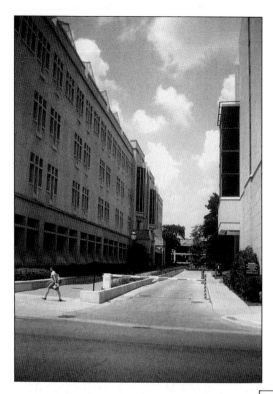

After purchasing and demolishing the properties on the west side of 5600 South Ingelside, the university requested that the street be closed to traffic. While the science buildings north of 57th Street at Ingleside Avenue slowly became a reality, the most effective and compelling building on the site is the Biological Sciences Learning Center (on the left). With a magnificently airy and light-filled interior, the building was a welcome addition to the north side of 57th Street. (Max Grinnell.)

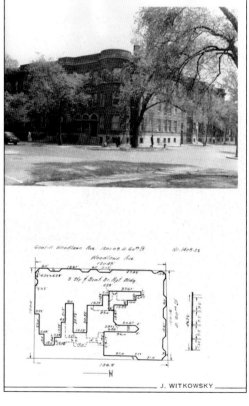

While the university began planning for new undergraduate dorms in the early 1950s, the housing problem involved with housing graduate students was largely solved by the aggressive purchasing of numerous apartment buildings and hotels in the area. This building at 60th and Woodlawn remains as one of the more popular options for graduate students at the university. (Private Collection.)

This rather unassuming one-story retail building at 6105–01 South University housed a ice cream store in the early 1950s. The building next to it was the location of some of the Manhattan Project experiments during World War II. (Private Collection.)

While most businesses around 55th and Lake Park moved westwards down 55th Streets, Morton's Restaurant moved over to 56th and South Shore Drive. While Morton's is now longer in Hyde Park, the restaurant has numerous locations across Chicagoland. (Private Collection.)

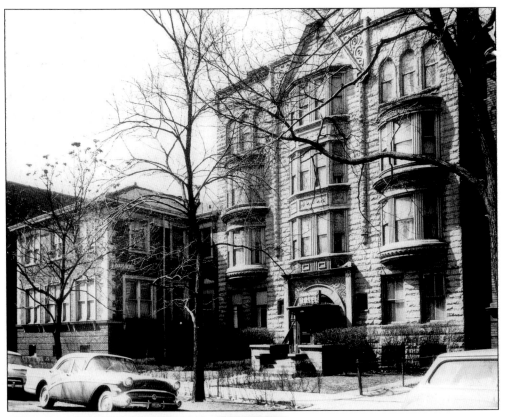

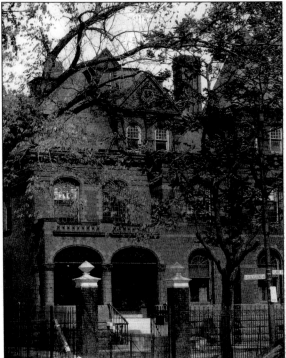

Located at 5714–20 South Blackstone, the Harvard Hotel was one of the buildings that served to justify the aims of urban renewal in Hyde Park. Again built for the World's Fair, the building had seen its fair share of criminal activity throughout the late 1940s and early 1950s, and was subsequently demolished by the City of Chicago. Several decades passed before the site was redeveloped. (Private Collection.)

The George Harding Museum at 4853 South Lake Park Avenue was a Hyde Park institution for decades until it was demolished by the city in 1965 to complete the widening of Lake Park Avenue from 55th Street to 47th. The Harding Museum contained a number of antique swords and other items from the medieval Europe which are now on display at the Art Institute of Chicago. (Private Collection.)